STOCKPORT
IN
50
BUILDINGS

PHIL PAGE

AMBERLEY

To all my friends and colleagues who live and work in Stockport.

First published 2023

Amberley Publishing, The Hill, Stroud
Gloucestershire GL5 4EP

www.amberley-books.com

British Library Cataloguing in Publication Data.
A catalogue record for this book is available from the British Library.

ISBN 978 1 4456 9774 1 (print)
ISBN 978 1 4456 9775 8 (ebook)

Typesetting by SJmagic DESIGN SERVICES, India.
Printed in Great Britain.

Contents

Map 4

Key 6

Introduction 7

The 50 Buildings 9

Bibliography 95

Acknowledgements 95

About the Author 96

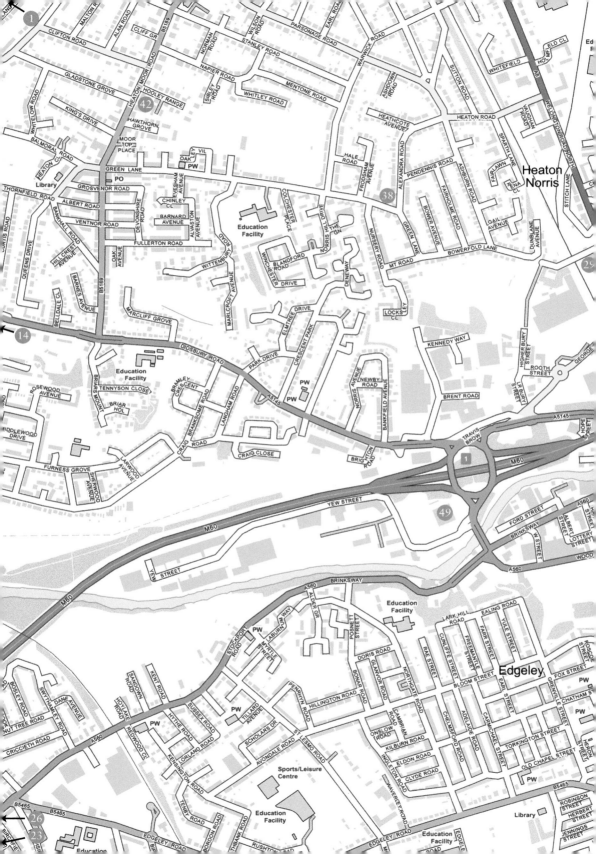

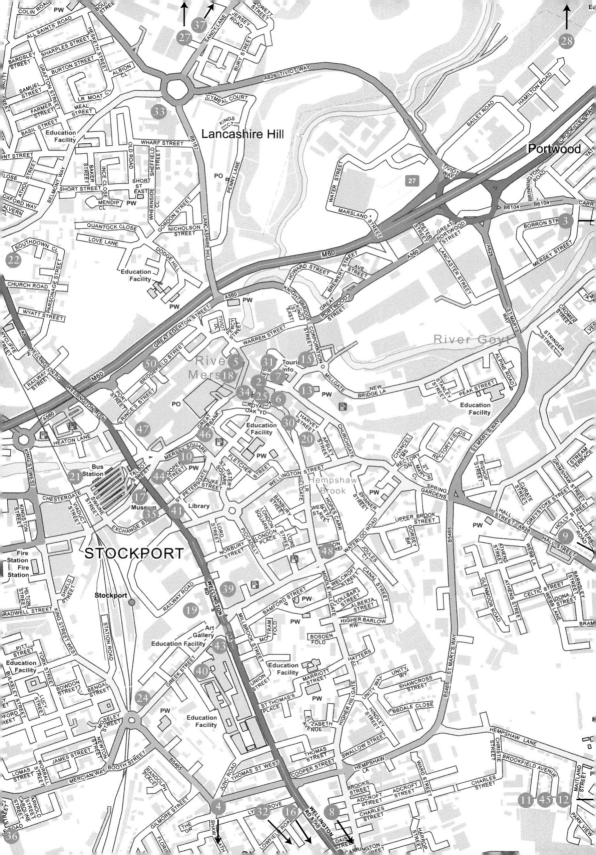

Key

1. Peel Moat
2. Stockport Castle
3. St Thomas' Church, Mellor
4. Bramall Hall
5. Underbank Hall
6. Stockport Dungeon
7. Staircase House
8. The Cage, Lyme Park
9. Chadkirk Chapel
10. St Peter's Church
11. Marple Aqueduct
12. Samuel Oldknow's Mill
13. St Mary's Church and Graveyard
14. The Crown Inn and Vale Cottages, Heaton Mersey
15. The Arden Arms
16. The Blossoms
17. Wellington Mill, Hat Works Museum
18. The White Lion Inn
19. Stockport Infirmary (Millennium House)
20. Robinsons Brewery
21. Stockport Railway Viaduct
22. Christ Church, Heaton Norris
23. Abney Hall, Cheadle
24. Stockport Armoury
25. St Petersgate Bridge
26. Barnes Hospital, Cheadle
27. Houldsworth Mill, Reddish
28. Reddish Vale Railway Viaduct
29. London & North Western Goods Warehouse
30. Winter's Jewellers Building, Little Underbank
31. Stockport Market Hall
32. St George's Church
33. Nelstrop's Flour Mill
34. The Bakers Vaults
35. The Garrick Theatre
36. Edgeley Park Football Stadium
37. Broadstone Mill, Reddish
38. The Almshouses, Heaton Norris
39. Stockport Town Hall
40. Stockport Secondary School
41. Stockport Central Library
42. The Savoy Cinema, Heaton Moor
43. Stockport Art Gallery and War Memorial
44. The Plaza Theatre
45. The Regent Cinema
46. Stockport Air-raid Shelters
47. Merseyway Shopping Precinct
48. Strawberry Recording Studios, 1967
49. The Pyramid Building, 1992
50. Red Rock, 2017

Introduction

Stockport developed as a town because of its location as an important ford over the River Mersey. It was the meeting point for several Roman roads and presented itself as a natural defensive position. After the Romans left, the Saxons constructed a village on the site. The Anglo-Saxon words '*stoc*', which refers to a marketplace or settlement, and '*port*', which is said to mean 'hamlet' or 'small settlement', are possible clues to the derivation of its name.

The first written recordings of the town's name date from around 1170 when it was known as Stokeport. Other forms of the name, such as Stokport, Stockporte and Stoppart, have appeared at different points in history, but the most lasting association has been with the name Stopford. Residents of the town are still referred to as Stopfordians.

The first building of any identity to be officially documented in Stockport was its castle, a twelfth-century motte-and-bailey construction from around 1173. The site is still identifiable today, but Stockport's architectural identity relates to more modern times. From the eighteenth century Stockport became a centre for the hatting trade and later the silk industry.

The town developed in size during the Industrial Revolution when its site at the confluence of the rivers Tame, Goyt and Mersey provided the water sources needed for the development of several mills engaged in the manufacture of silk and hat making. Throughout the nineteenth century, spinning, weaving, bleaching, printing and dyeing became the staple industries of Stockport and many of its surviving buildings reflect its industrial heritage. The old mills, churches and market buildings still play an essential part in the life of the town today. The existing breweries, cinemas, libraries, art galleries and railway stations are a reflection of the needs of a growing Victorian and Edwardian society. The grand constructions of their age can still be seen, with Wellington Mill, Stockport Armoury and the famous railway viaduct that crosses the river being among the most impressive examples of a great industrial age.

The oldest linear route into the town is characterised by the Three Hillgates (Upper, Middle and Lower), which create a strong sense of arrival for travellers entering the town from the south. Today a walk around the narrow streets and passages of this area provides evidence of Stockport's rich history, with the fifteenth-century Staircase House and the quaint, cobbled streets surrounding the market sitting in the shadow of the historic St Mary's Church. Venture out of

the centre, however, and you will find Stockport is rich in myth and legend. From the witch of Reddish Vale and ghosts of Bramall Hall to the industrial legacies left by Samuel Oldknow, there is always something to catch the imagination of those visitors who wish to enjoy the architecture and history of the many fine buildings that survive to create the character of the town.

The 50 Buildings

Peel Moat can be accessed along a path that makes its way through Heaton Moor Golf Course. It's an inauspicious piece of ground, surrounded by water and populated by local wildlife. At first glance it has the appearance of an artificial lake, but it's been there for many years – several hundred, in fact.

What we can probably assume about Peel Moat is that it's some sort of earthwork. The site is a perfect square, its sides facing geometrically north, south, east and west. The outer sides of the moat measure 220 feet and the raised inner sides are about half that distance.

One theory is that it may have been a moated defensive site similar to many other medieval structures dotted around Lancashire and Cheshire. The general

The site of Peel Moat on Heaton Moor Golf Course.

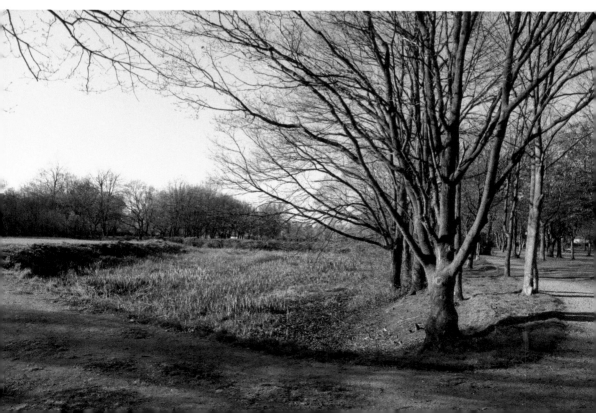

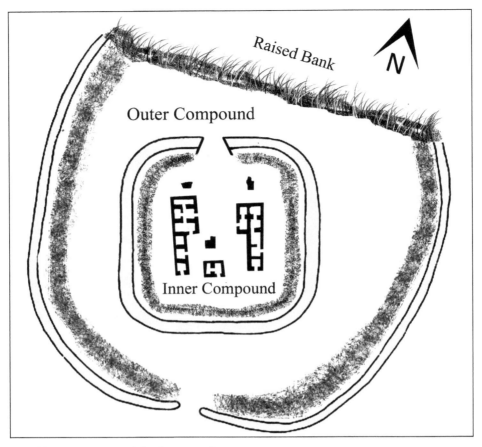

Possible construction of the fort at Peel Moat.

feeling among archaeologists, though, is that it is too small, has no recorded medieval buildings and is not fed by a stream or river, which would provide additional defensive barriers. It is also not set in a particularly defensible location, given that the area around it is completely flat.

If the theory is correct Peel Moat was probably annexed to Castlefield Fort, which would have sent men and supplies and taken messages from the site. Peel Moat may have been one of several signal stations heading south out of the city, possibly in the direction of Chester. The structure also lies between two known Roman roads – Burnage Lane and Manchester Road – with the centre of the moat exactly 2,500 feet from each one. Local tradition has it that the site was sacked by Cromwell's troops during the Civil War and some documentary sources from the time describe the monument as having a square, fortified tower.

Roman signal towers of this type are commonly found across the militarised frontiers of the Western Roman Empire, from the Gask Ridge in Scotland to the Rhenish Limes in Germany. The tower, constructed of timber, was likely

garrisoned by a *contubernium* of eight soldiers who lived on site. If Peel Moat was such a structure, it would have been in sight of other signal stations, allowing warnings to rapidly reach the larger garrison at Castlefield Fort.

2. Stockport Castle, 1173

Stand between the Boar's Head and the Bakers Vaults and you are in a location once known as Castle Yard. There is clear evidence that this was once the site of Stockport Castle, which was held by Geoffrey de Constantine against his father, Henry II.

The site of the castle was on a 10-metre-high sandstone spur, which at the time overlooked a ford crossing the River Mersey. The castle was flanked by cliffs or steep slopes on its north, south and west sides. It is reasonable to assume it was a motte-and-bailey castle typical of the medieval fortifications in England at the time.

By 1173 the building had likely fallen into ruin, as we know that by the late fourteenth century the estate had passed into the hands of the de Warren family, who preferred to live in their manor house in Poynton and not in the castle. It was described as 'ruinous' when Henry VIII's librarian, John Leland, visited the town between 1535 and 1543.

The ruins of the castle were eventually demolished in 1775 to make way for the construction of a large round tower, which was intended for muslin manufacture but never became a commercial success.

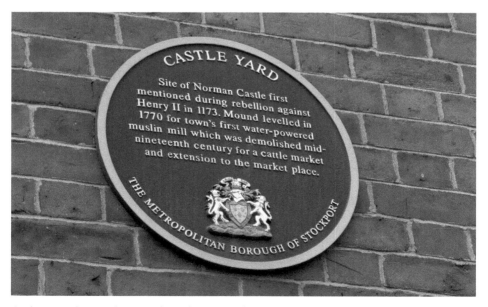

A plaque indicates the site of Stockport Castle in Castle Yard.

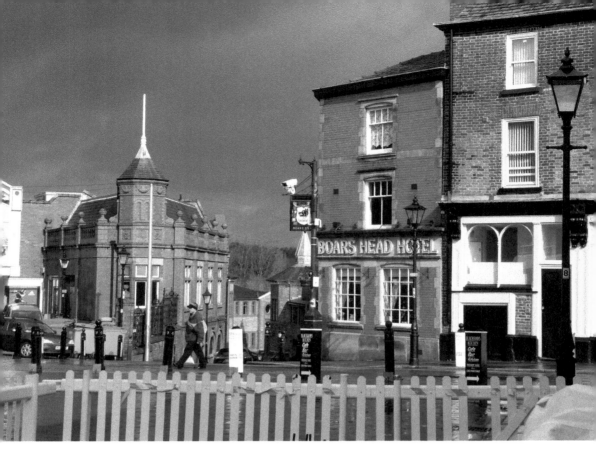

Castle Yard, near the Market Place, is the original site of the castle.

3. St Thomas' Church, Mellor, Fourteenth Century

St Thomas' Church in Mellor clings to the very edge of the borough of Stockport. It is the highest church within the boundary and enjoys an elevated position with views across the whole of Cheshire to the Welsh Hills, Liverpool and Lancashire.

The origins of the church can be traced to the middle of the early fourteenth century, just before the Black Death. At this time the site probably contained a stone building and it is possible that a wooden structure once existed, but there is no evidence for this. The tower of the modern church can be dated to the fifteenth century.

The eighteenth century saw many changes to the fabric of the church. In 1783, the walls were partly rebuilt and galleries on the south and east walls were constructed. The roof of the chancel was raised to accommodate a new organ and seating for the choir.

The interior of the church contains two important items of furniture: the fourteenth-century pulpit and the Norman font. The pulpit is unique in England and is said to be the oldest wooden pulpit in the country – possibly in the world.

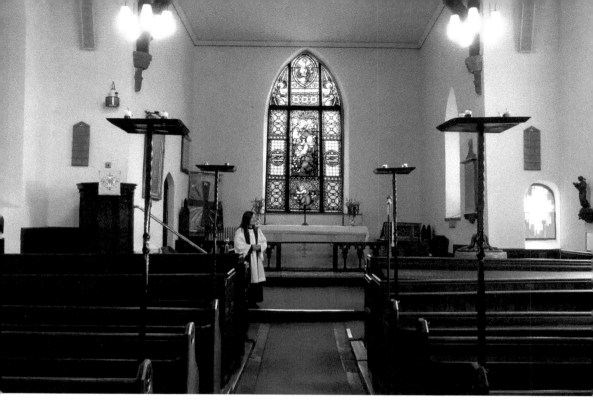

Above: The interior of St Thomas'
Church, showing the pulpit and font.

Right: St Thomas' Church sits high on a
hill overlooking the village.

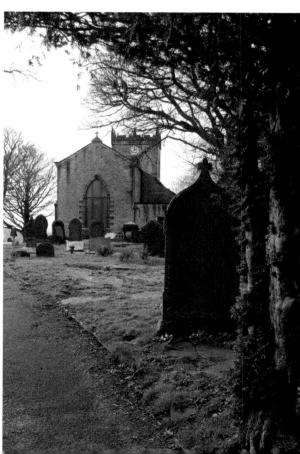

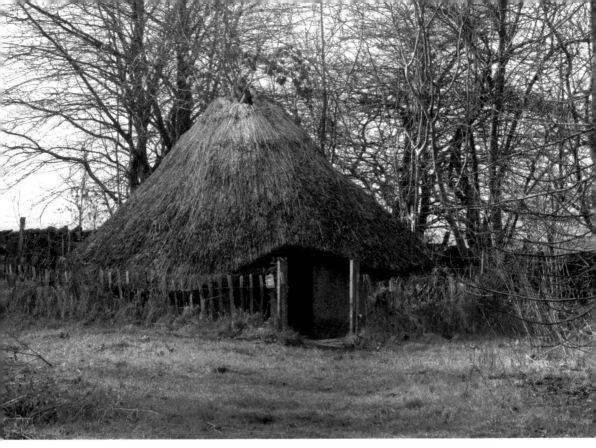

A reconstruction of an Iron Age roundhouse sits next to the church.

It dates from the time of Edward II. The font dates from the eleventh century, but there are no records to tell whether it was constructed before or after the Norman Conquest. The bowl is carved with an incised design of figures and animals, and the basin is lined with lead.

A new entrance and porch were built in 1815 and a smaller door into the tower was made. In 1926, the three old bells were melted down and recast into the one that is heard today. Electric lighting replaced oil in 1947.

There are some treasures to be found in the churchyard, including the sundial with its supporting column made from the remains of a late medieval cross and the end posts of the old village stocks. There is also the headstone of Thomas Brierley (who died in 1855), which is carved with Masonic symbols, and the graves of two soldiers of the First World War.

4. Bramall Hall, Fourteenth Century

Bramall Hall is situated on 70 acres of landscaped parkland approximately 3 miles south of the centre of the town. It is a well-preserved, black-and-white,

timber-framed Tudor manor house that was built by the Davenport family, with its oldest parts dating back to the fourteenth century.

The legacy of the Davenports of Bramall Hall can be found all around Stockport and within the county of Cheshire. They remained there for 500 years before selling the estate in 1877 to the Manchester Freeholders Company. The estate then passed through several owners, including the Nevill family, John Henry Davis, and Hazel Grove and Bramhall Urban District Council before passing on to Stockport Metropolitan Borough Council.

As befits a building of such age, legends of ghosts and spirits abound. An old ballad tells of Alice, or the 'Maid of Bramall Hall'. She was eagerly awaiting the return of her lover from Spain and was horrified when his horse arrived without its rider. Her lover's body was discovered in Macclesfield Forest, murdered by highwaymen. She mourned him until she died and still haunts the room, where she eventually gave up her life.

An alternative story about Bramall Hall's female ghost says she is Dame Dorothy Davenport, wife of William Davenport, the original builder of the hall. Her bedroom is so badly haunted that it has earned the sobriquet of 'the Ghost Room'. Visitors to this room sometimes hear rustling skirts or feel a hand on their shoulder – at least one visitor has even heard a voice saying 'Hello'. A shadowy woman has also been seen in the Plaster Room, passing through the wall into the Withdrawing Room next door.

Bramall Hall and gardens from the rear.

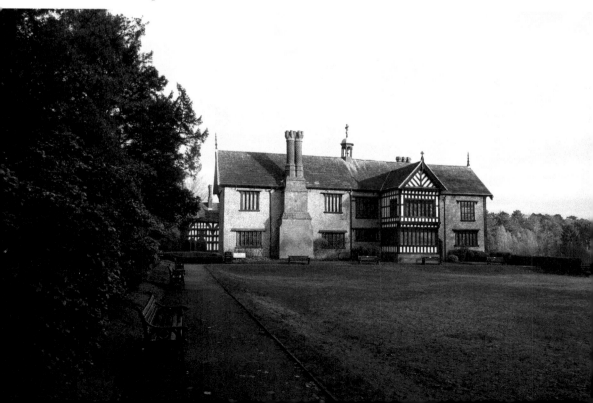

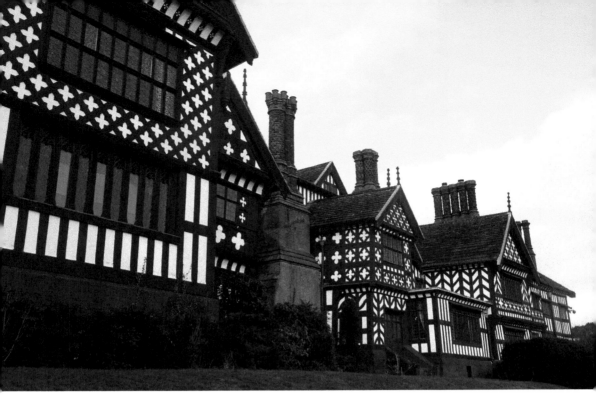

The front of the hall with its black-and-white timber framing.

In 2016, the house and surrounding buildings were restored and refurbished following a £1.6 million restoration programme by the Heritage Lottery Fund. Improvements have been made to the historic rooms, the architecture and the fabric of the building. The stable block has been converted into a visitor centre that houses a gift shop and classroom facilities. The new glass-fronted café opens onto the walled garden for outside dining.

5. Underbank Hall, Fifteenth Century

Underbank Hall is a fifteenth-century Grade II* listed building. It was originally a townhouse for the Arden family of Bredbury. William Arden (1789–1849) was a British Army officer in the Coldstream Guards. He was a prominent member of the Prince Regent's circle and was friends with Beau Brummell. In some social circles he was regarded as the wittiest man of his day. With the help of friends he formed the Watier's Club, which was popular with Lord Byron, who nicknamed it 'the Dandy's Club'. He continued to be a friend of the Prince Regent, but at a masquerade ball in 1813 his friend Brummell spoke inappropriately to the Prince and his favours were lost.

He continued to lead an extremely lavish lifestyle, funded by income generated by the estates that his father had bought. He made the mistake, however, of using his influence to broker credit. When this got out of hand his family estates had to

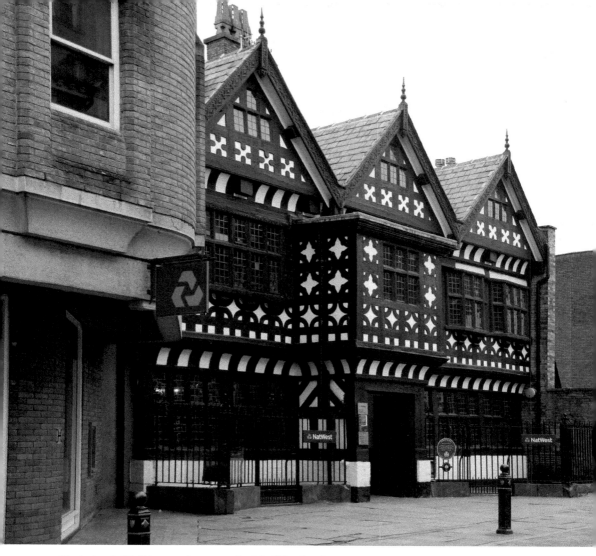

Underbank Hall is now home to the NatWest bank.

be sold to pay them off. Underbank Hall in Stockport was sold by auction in 1823 and most of the Bredbury estate was sold in lots in 1825.

Today the building still retains a financial connection, being a branch of NatWest.

6. Stockport Dungeon, Fifteenth Century

Mealhouse Brow, previously known as Wynn Hill, was one of the main access roads linking Lower Hillgate with the market and castle before the building of St Petersgate Bridge. At the top of the Brow is Stockport Dungeon.

The dungeon was directly beneath the court leet magistrates' court. The court leet was empowered to hear and punish all crimes in the town. It developed from the portmoot, or portmote, an early justice system used in many cities and boroughs. It was usually comprised of burgesses, the chief of whom came to be known as mayor. The courts appointed all officers of the town, including constables, market overlookers and bailiffs.

Punishments handed out were traditional and often severe. One of the most vicious was the use of the brank, an iron-looped hood with a spiked tongue piece. It was used mainly on women convicted of riotous or troublesome speech. A spike inside the gag prevented any talking since any movement of the mouth could cause a severe piercing of the tongue. The ducking stool was another popular punishment, and Stockport had two locations for this: one at Daw Bank near the present bus depot and another at Cale Green. Imprisonment in the stocks was also used. They were originally situated in the market square but eventually moved outside of the dungeon when the language of offenders became too offensive for churchgoers.

The Market Place, however, was the location for the pillory, a contraption similar to the stocks but which required the offender to stand and be pelted with anything that came to hand. Flogging was also used before imprisonment in the dungeon. A whip with nine lashes was administered to the bare back and used to punish minor crimes such as petty theft.

Stockport Dungeon is situated at the top of Mealhouse Brow.

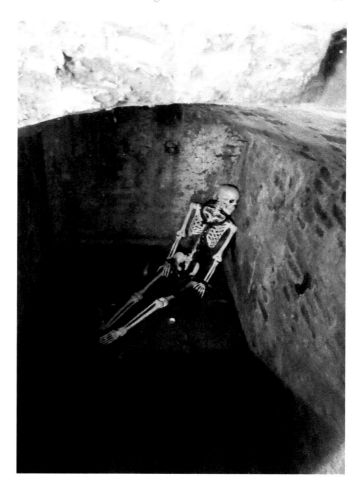

The cells inside the
building.

Conditions for those locked in the dungeon were not particularly pleasant.
Prisoners were held in the small, dark cells beneath the ground, which were
accessed through the main door or from the small wooden entrance on the side of
the Brow.

7. Staircase House, 1459–60

Staircase House, in Stockport Market Place, is a cruck timber building with its
earliest known surviving timbers dating from between 1459 and 1460. The early
history of the property is largely unknown although it may have been the home of
William Dodge, who in 1843 was the Mayor of Stockport.

The property owes its survival to a long and hard-fought campaign by the
Stockport Heritage Trust which was formed in 1987 and became a charitable trust
the following year. The trust members successfully argued that the house was one of

Stockport's most unique discoveries and should be preserved for future generations to enjoy. After underwriting a loan from the Architectural Heritage Fund the compulsory purchase of the property took place and a programme of restoration commenced. Stockport Heritage Trust raised a considerable amount of money to aid the reconstruction of the house and members freely gave their services, in many cases using their own money to pay for various studies and investigations.

As the restoration commenced, a history of the building began to be uncovered. It was discovered that the first residents were the Shallcross family, who owned the house from 1605 to 1730. They were wealthy, landed gentry from Derbyshire and in 1618 installed the distinctive Jacobean cage-newel staircase, from which the house takes its modern name. The staircase has some unusual features in that each of its newel posts extends throughout the full height of the staircase, the four posts and the bannisters thus forming a stairwell that is not fully enclosed but contained within a cage-like structure. Some modifications to the newel posts took place in the nineteenth century: each was sawn through – possibly to overcome the practical difficulties of moving large objects, such as furniture, about the house.

Below left: The rear of Staircase House before renovation.

Below right: The visitors' entrance in the Market Place.

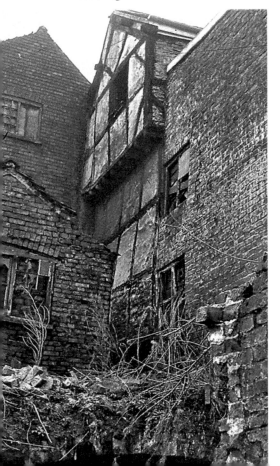

The rooms feature period colours, furniture and artefacts that reflect its long and eventful history. The bedroom contains a seventeenth-century four-poster bed and there is a 200-year-old table in the eighteenth-century dining room. The kitchen is similarly authentic with a close eye on detail and even some historic lighting in the tallow room. There are also rumours of spirits and the house is said to be haunted by the ghost of Robert Owen, former butler to the Shallcross family. The house is now Grade II* listed building.

8. The Cage, Lyme Park, 1580

Lyme Cage sits on a ridge of high ground inside the Lyme Park estate overlooking the nearby moors and 1,300 acres of parkland. It is accessible via a path that runs north approximately 650 metres from the entrance to Lyme Hall.

The Cage was built around 1580 as a hunting lodge where ladies of the nobility could watch on as their menfolk hunted stags on the slopes below. In the evening the tower would become a banqueting hall for feasting, drinking and celebration.

In later times the tower was lived in by the estate's gamekeeper and one of the rooms in the tower was strengthened and used for locking up poachers who had been caught trying to hunt hare and deer.

Lyme Cage on a crisp winter's day.

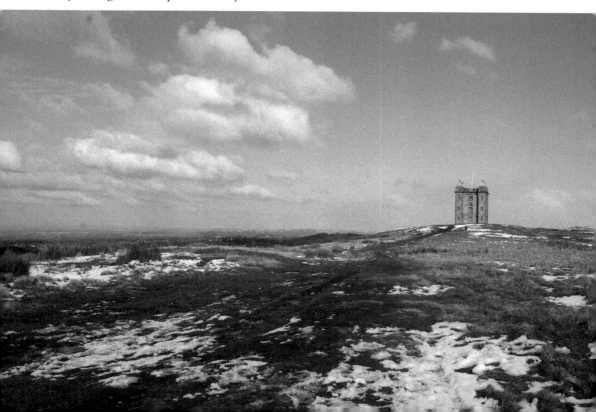

The original tower survived until 1734 when the existing structure was largely dismantled by George Platt. It was rebuilt in 1737 by Peter Platt on behalf of Peter Legh XII (1669–1744). The tower is of similar design to the central keep of the Tower of London. The design may well have been deliberate, as Peter Legh XII was imprisoned twice in the Tower of London on charges of treason.

The reason why the structure is called the Cage is something of a mystery, but it may well be a reference to how Legh felt about his imprisonment or simply a reference to the tower's earlier use as a poacher's prison.

9. Chadkirk Chapel, Restored 1747

Chadkirk Chapel sits peacefully tucked into a corner of the Chadkirk Country Estate on the border of Romiley and Marple. The name Chadkirk means the 'chapel or church of St Chad'. St Chad was the Bishop of Lichfield and probably founded a monastic cell on the site around 670 AD.

The original building is thought to date from the sixteenth century, but in 1747 it underwent a significant programme of restoration funded by money raised through public subscription. During this period the south walls were completely rebuilt. Today it is a fine example of a timber-framed building with a slate roof and attractive white walls of dressed stone. The bellcote at the west end of the chapel is Georgian. The bell itself was repaired and rehung in 2000 and displays its original inscription, 'In God We Trust 1752'.

The gardens are an attractive feature of the location.

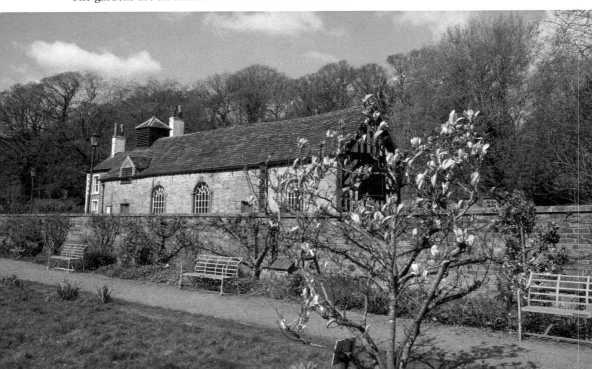

During the sixteenth century the chapel was used as a chantry where Masses were conducted for the souls of the dead, but these practices were suppressed under Edward VI. The chapel then went through various stages of use as a family chapel under the Davenport family. It was a Puritan place of worship in the 1640s and a Nonconformist meeting place in the late 1600s. In 1705, however, the Nonconformists were evicted and by 1747 it was in the possession of the Church of England and restored by money raised from public subscription. In 1971, the chapel was declared redundant and sold to the local district council. In 1973, ownership was passed to Stockport Metropolitan Borough Council, which has been responsible for its care ever since.

Alongside the chapel is a fine walled garden, which was probably laid out by the Nicholson family, who owned the estate from 1745. Originally, it would have been used as a kitchen garden growing produce for the inhabitants of Chadkirk House. Beehives were placed in the orchard to encourage pollination and contribute to a good crop of fruit and vegetables. The garden is now supported and maintained by the Friends of Chadkirk.

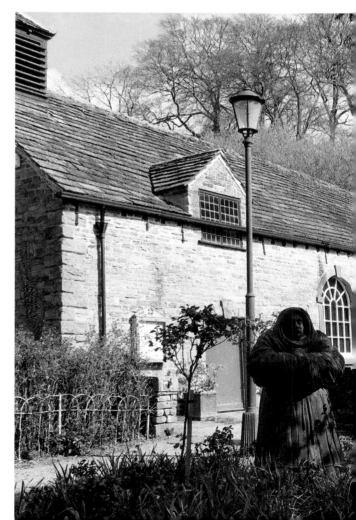

The entrance to Chadkirk Chapel.

10. St Peter's Church, 1768

St Peter's Church sits in an elevated position on the curve of St Peter's Square as it rises away from the town centre. It is Stockport's second-oldest parish church and is a designated Grade II* listed building.

The building is a distinctive feature of the area and has several unusual aspects to its design. It consists of a nave, an apsidal chancel, and a west tower flanked by vestries. The tower has three stages. The lower two stages are square and the top bell stage is octagonal with a copper-roofed dome.

The church was built in 1768 at the sole cost of William Wright. A gallery was added in 1838 and an apse in 1888–89. Vestries flanking the tower were added in around 1838 and the chancel was built in 1888. The church is in brick with stone dressings and a slate roof.

The interior of the church is light and spacious. At the west end is a gallery. The front of the church is panelled and has a coloured shield of arms depicting the crossed keys of St Peter. Under the gallery is a white marble font. On the north wall of the chancel are three marble mural tablets, which are to the memory of William Wright, the founder, and two of the early vicars

St Peter's Church viewed from Petergate.

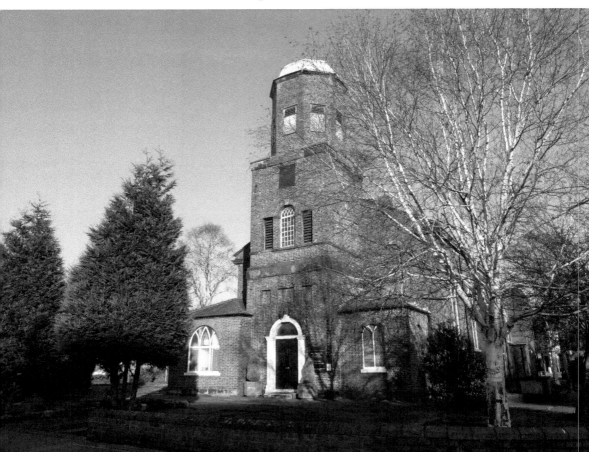

of the church. Also in the church is a hatchment from the eighteenth or early nineteenth century to a member of the Wright family. There is one bell dated 1768. The Communion plate includes a chalice and a paten dating from 1768.

Also present is a chair frame clock, formerly in the bell tower, now restored to working order by Philip Quale and Alan Newton. It is claimed that this is the oldest working public clock in Greater Manchester. It was installed just after the church opened in 1769 and was made by John Whitehurst (1713–88) of Derby.

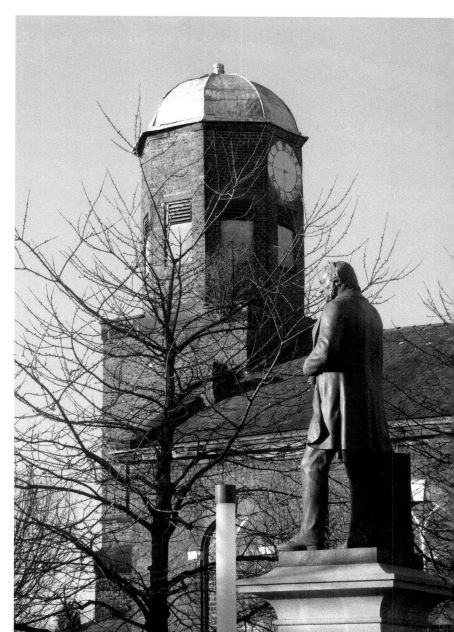

Cobden's statue now sits in the area outside the church.

11. Marple Aqueduct, 1799

This graceful structure can be located by a short walk along the Peak Forest Canal from the centres of either Marple or Marple Bridge. It was completed in 1799 and was in full service the following year. It was designed by Benjamin Outram and built under the supervision of the engineer Thomas Brown. It was built to carry the lower level of the Peak Forest Canal across a length of what, at the time, was the River Mersey (renamed the River Goyt in 1896). Seven men lost their lives during its construction.

It has the distinction of being the highest canal aqueduct in England and the highest masonry-arch aqueduct in the UK. It rises 90 feet from the river and contains some 8,000 cubic yards of masonry. The lower parts of the aqueduct are constructed from red sandstone mined locally at Hyde Bank Quarry. The upper parts are of white stone from a quarry at Chapel Milton, near Chinley in Derbyshire.

In 1962, it was saved from demolition by Geoffrey Rippon, the Minister of Public Buildings and Works. On the night of 9 January the outer north face of one of the arches collapsed, and the Ministry of Transport considered it too costly to repair. They proposed that it can be demolished and that this section of the Peak Forest and Ashton Canal be permanently closed. Rippon came to an agreement with Cheshire County Council to provide money to save the aqueduct, and

The aqueduct wall looking west.

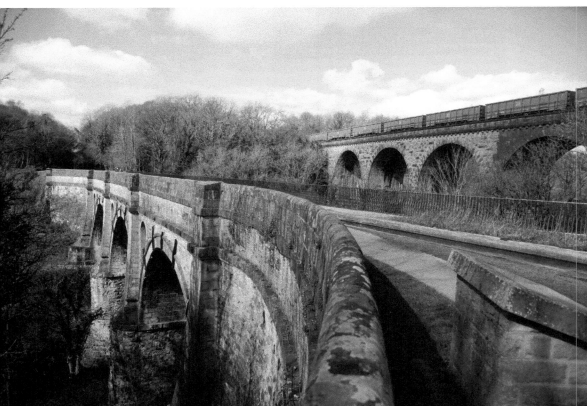

restoration was completed by Faircloughs of Warrington. Shortly after the works were completed, it was scheduled as an ancient monument and became a Grade I listed building in 1966.

Lots of work to improve the area around and beneath the aqueduct is regularly undertaken by Marple Aqueduct Conservation Volunteers. They have built a path and steps which allow visitors to descend into the woodland below and view the structure from beneath. They also sow wildflowers, clear away weeds, carry out nature surveys and look for ways that the environment around the aqueduct can help local plant and animal species. The aqueduct is bordered by two areas of ancient woodland, and this section of the Peak Forest Canal carried by the aqueduct is a Site of Special Biological Interest.

12. Samuel Oldknow's Mill, 1790

There can be few people who have had such an impact on the industrial development of the town as Samuel Oldknow. On the road from Marple to the Roman Lakes stood his magnificent cotton mill and his private mansion, Mellor Lodge.

The Mellor Mill was a six-storey-high brick building and, at the time, it was the world's largest spinning mill. As part of its construction the River Goyt was diverted, three millponds were created, and a system of tunnels, channels and wheel pits were built. The millponds remain to this day and are called the Roman Lakes. They were given the name in Victorian times and subsequently became a huge tourist attraction.

The mill dominated the valley and provided work for hundreds of people, but on a foggy night in November 1892 a fire took hold of the building, and its end was fast. The blaze went unnoticed until 2 a.m., by which time it had gained a firm hold and there was no hope of checking it. By 8 a.m. nothing remained standing except the towering, fire-blackened walls. The full horror of the event was recorded in the local newspaper.

> The spectacle, when the fire was at its height, was a splendid but awe-inspiring one. The entire mass of buildings, which covers half an acre in area, was in a gigantic blaze, brilliantly illuminating the district. Huge columns of smoke ascended into the heavens and hung in the form of a dense canopy over the burning building. One by one the floors fell in with a deafening crash and the machinery clanged together like the roar of artillery. The mill girls with their shawls over their heads, the children clinging, terrified, to their mother's dresses, and the men who had been striving to render what little assistance there was in their power, were all gazing at the burning pile …

After an extensive period of excavation the remains of the mill are now open to public viewing, nestling sleepily in the now tranquil setting of the wooded valley.

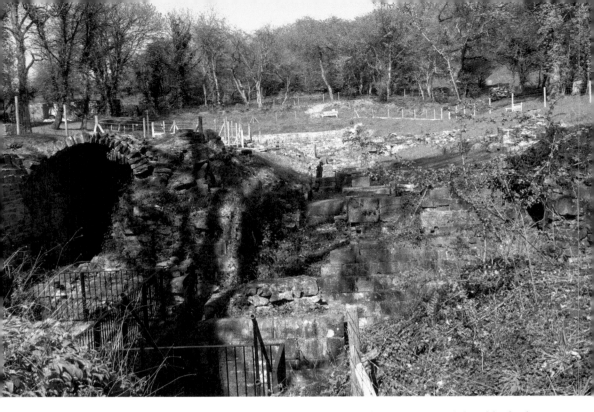

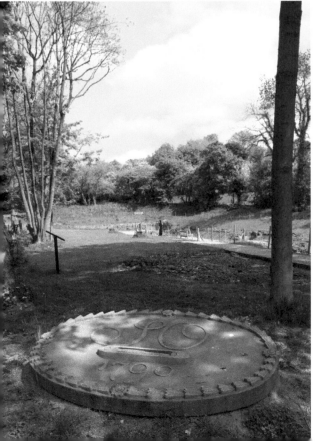

Above: The excavation of the old wheel housing.

Left: An old mill wheel now records the date of the mill's construction.

13. St Mary's Church and Graveyard, 1813–17

St Mary's Church is the oldest parish church in Stockport and stands on Churchgate overlooking the market. Although it is dedicated to St Mary, it was originally dedicated to All Saints. It is a designated Grade l listed building. The gateway to the church, which was designed by Lewis Watt, is Grade II* listed, as is the drinking fountain that stands nearby.

There has been a place of worship on this site since before Norman times. The first official record of a church on the site dates from around 1190, but of this original structure only the oratory remains. Around 1310, records of a new church appear, with the chancel remaining from the earlier building. The present church was constructed between 1813 and 1817, with further restoration in 1848. The church tower, which dates from the fourteenth century, was rebuilt twice, in 1616 and 1810, some five years after a partial collapse that was blamed on a marathon bell-ringing ceremony to celebrate Nelson's victory at Trafalgar. A hundred years ago the church was very much part of the marketplace and the verger would be making charges for setting up market stalls against the church wall and selling tea to the visiting gentry. Church services were always a source of revenue, and in 1715 the charges were 4*d* for a christening, 1*s* 8*d* for a marriage, 5*d* for an adult burial and 2*d* for that of a child. The wealthy could be buried in the chancel for the considerable sum of 6*s* 8*d*.

The gravestones cover the side and rear of the church.

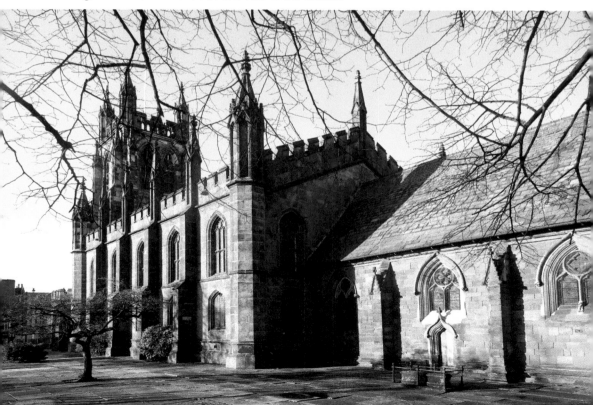

The graves that surround the church give a fascinating record of some of the people who are important to the history of the town. A comprehensive study of the graves was completed by Jill Tumble in 2009 when all the gravestones were transcribed by hand and details checked against existing parish records. The graveyard was landscaped between 1968 and 1971, and the gravestones now visible are those that were selected to remain. Some of the more famous graves were relocated to make them more accessible to the public and can now easily be found by visitors to the churchyard.

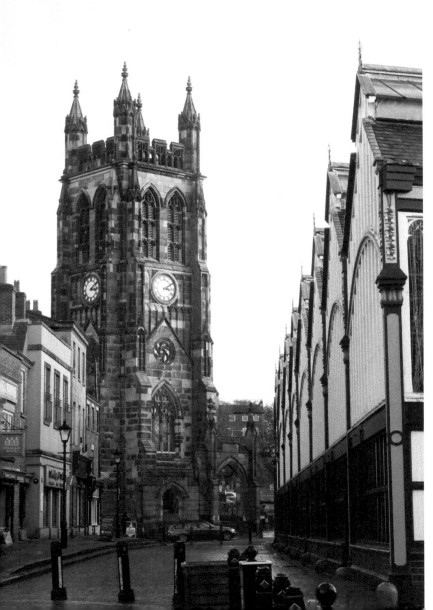

St Mary's viewed from the Market Place.

14. The Crown Inn and Vale Cottages, Heaton Mersey, Late Eighteenth Century

The area around the Crown Pub, Vale Close and Park Row must be one of the oldest and most attractive parts of the Heatons. The collection of half-timbered buildings and quaint workers' cottages with cobbled streets winding lazily down towards the Mersey are a reminder of the days when Heaton Mersey was a rural village sitting at arm's length from the smoke and industrial clamour of nearby Manchester and Stockport.

The Crown forms part of a group of buildings that were originally a tiny hamlet beside Parrs Fold and Vale Road, which together with the hamlet of Grundy Hill, just to the west, were the core of what later became the village of Heaton Mersey. The Crown was possibly built to serve local drovers or stockmen who would rest their animals overnight at Parrs Fold as they drove their horses and carts along Didsbury Road, which formed part of the old salt way from Manchester to Northwich.

As road traffic grew during the second half of the eighteenth century the position of the Crown was enhanced and the pub developed a reputation as a 'Tom and Jerry' shop. The word 'Tom', referring to a male animal, suggested that the Crown was almost exclusively the domain only of men. The word 'Jerry' was local slang for a low public house or beer shop. Sometimes such premises were unlicensed but usually were allowed to sell beer, ale (without hops) and porter.

The Crown and Vale cottages in a snowy January.

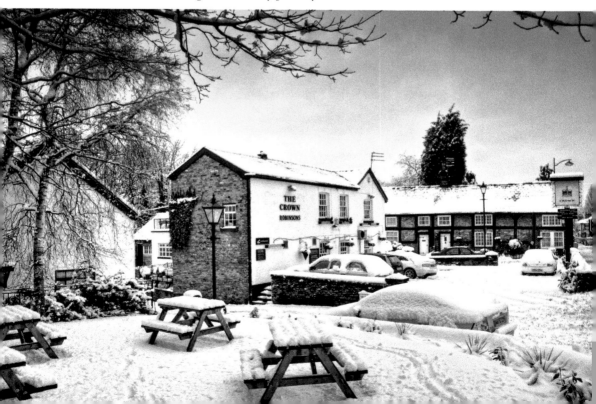

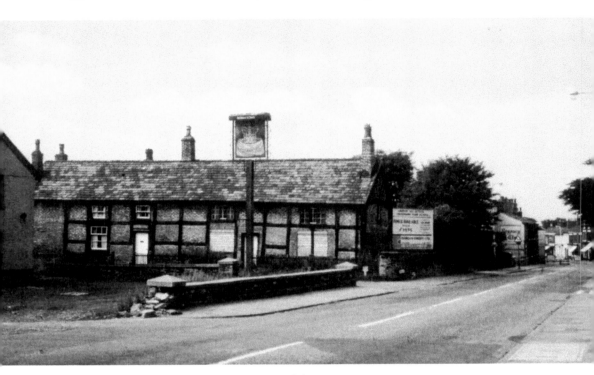

In the 1970s the cottages were in a state of disrepair.

The more disreputable houses sold 'Jerry beer', which was of poor quality, usually home-brewed and referred to as 'hooch'. The Crown did not obtain a licence to sell spirits until around 1833.

After its licence was granted the Crown also made use of its ovens, opening a commercial bakery. The practice was likely started around 1814 by Samuel Dutton who produced not only bread but other popular items such as seed cake and hot cross buns.

The Crown was eventually modernised in the mid-twentieth century and today is a Grade II* listed building.

15. The Arden Arms, 1815

The Arden Arms, at the junction of Millgate and Corporation Street, must have one of the best-preserved interiors of any pub in Stockport. Walk through its front door and you'll find the old, wooden, curved bar, original sash windows, tiled floors, grandfather clocks and antique sideboards, which take you back to a bygone age of town centre drinking.

The pub was built in 1815 by George Raffald, with the land and permission to build the pub granted by Stockport Corporation in exchange for part of a nearby

field through which they wanted to build a new road. The Raffald family had been gardeners and seedsmen for generations owning land along the banks of the Mersey and the Arden was built on land belonging to the furthest corner of the family's orchard. George Raffald sold the orchard soon afterwards, but the pub was kept within the ownership of his family and even had its own brewhouse until 1861.

The pub was eventually bought by Robinsons Brewery in 1899, and another pub, the Old Crown Inn, and a shop adjoining the Arden's buildings were demolished. The old stableyard has always been a feature of the pub, and the aerial photograph from 1979 shows the open spaces around the building and the County Pub, which stood next door. Both have now been replaced by a modern shopping complex.

One of its most intriguing features is its snug, or 'select', which can only be accessed by passing through the bar with permission from the staff. The Bridge Inn at Topsham in Devon and Ye Horns Inn at Goosnargh in Lancashire are the only two other pubs in the country that have a similar bar arrangement.

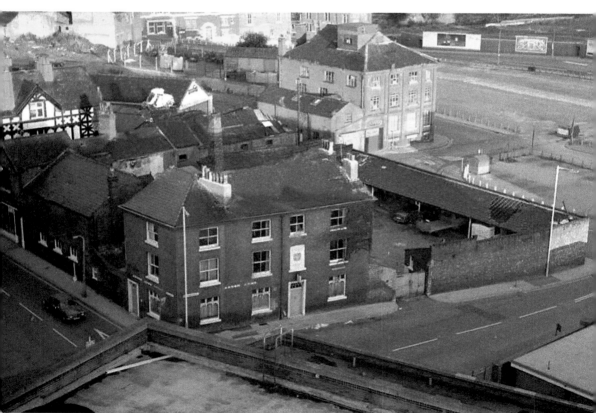

An aerial shot of the pub taken in June 1979.

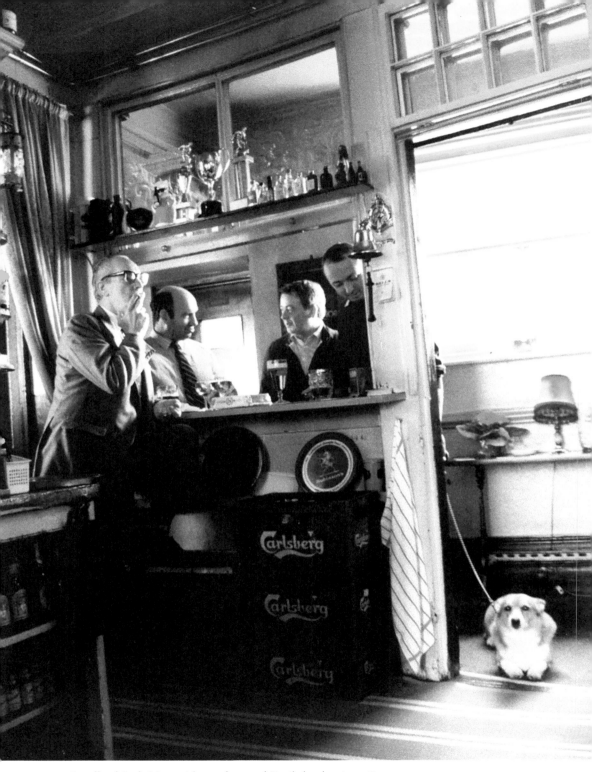

Landlord Jack May with regulars and Basil the dog in 1981.

16. The Blossoms, 1824

The Blossoms is a landmark pub dating back to 1824. This Grade II* listed former coaching house has an unusual triangular shape due to its corner location, and has survived unscathed from the fashion for open-plan pubs in the later part of the twentieth century. That the interior is largely unspoilt is due mainly to the care and attention given by Mary Body, who served as the licensee from 1942 to 1967. The pub still retains its vintage seating and original stained-glass windows. It boasts small, intimate rooms, a central curved bar and a good-sized first-floor function room, home to several societies and well used for local gatherings. The location of The Blossoms is historically significant as it marked the southern entrance to the toll road, which ran along the Hillgates, through the town and up Lancashire Hill to Heaton Chapel.

The pub recently gave its name to Stockport's award-winning indie band, Blossoms. The band decided to name themselves after the pub after two of the band's members thought it sounded particularly cool. Now the name of the small pub on the A6 is known across the UK, Europe and the USA.

The Blossoms sits on the corner of the A6 and Bramhall Lane South.

Top-selling indie band Blossoms take their name from the pub.

17. Wellington Mill, Hat Works Museum, 1830–31

Stockport Hat Works Museum is housed in this seven-storey brick building, which is now Grade II* listed. Wellington Mill, built between 1830 and 1831, was originally a cotton-spinning mill and became a hat works during the 1890s. The mill was designed by Thomas Marsland and was one of the early mills to have a fireproof cast-iron structure. The chimney, which is 61 metres high, was added in 1860. The museum celebrates the legacy of hat making in the town.

It tells the story of the early roots of Stockport's industrial heritage that can be found in the cloth and wool merchants who were operating in the borough in the fifteenth century. Woollens and linens were being produced in large quantities by the sixteenth century.

Hatting was introduced into Stockport in the 1650s, with manufacture carried out in domestic workshops by felt makers using tools and processes that would still be recognisable 200 years later. Some hats were sold to the local market, but the skills of the workforce soon came to the attention of major hatting firms in London, in particular Christys, who began to commission work from factories in the town.

The firm first moved into the town in 1826 when it took over a mill owned by the Worsley family. The Worsleys had been producing hats exclusively for Christys since the 1780s. But by 1840 felt hat making in Stockport was on the verge of collapse. Hatters were put onto shop time, and workers were said to be suffering 'great distress and destitution'.

A saviour was at hand in the shape of William Barber, who learned silk hat-making skills and invented new machinery to turn the Christy factory around. Stockport eventually became the centre of the country's hatting industry, which by 1884 was exporting more than 6 million hats a year.

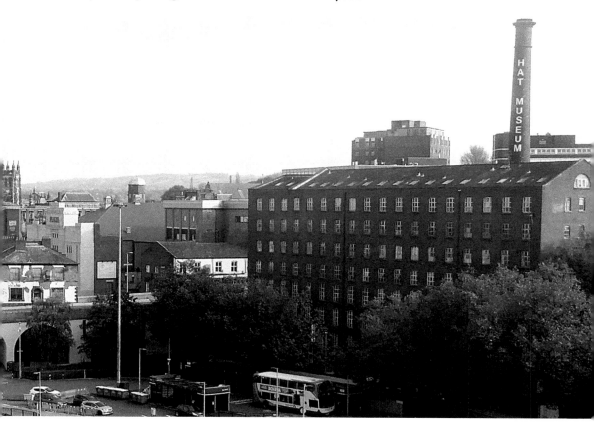

Above: The mill chimney is one of the town's landmarks.

Right: The entrance to the hat museum on Wellington Road South.

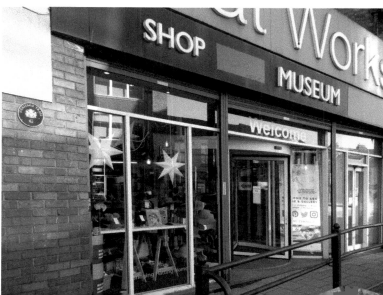

18. The White Lion Inn, 1832

The White Lion is a Grade II* listed building on Great Underbank, in the town centre. It was originally a coaching inn and was first granted a licence in the fourteenth century. At one time there was a bowling green next to the rear of the inn, which adjoined the gardens and pleasure grounds behind Underbank Hall. The pub's garden led down to the River Mersey and it was rumoured that guests were entitled to fish for salmon during their stay. The inn was given a new frontage in 1832 and has undergone some rebuilding in recent years.

The inn was conveniently situated a short distance from what at the time was the only crossing point of the Mersey, at Lancashire Bridge. Another advantage of its location was that it was built where the three main roads to the south, east and west converged. At one time it was the main posting house in Stockport and could hold up to twenty horses at any given time in its stables. The mail coaches would bring news of events, particularly during the country's conflicts with Napoleon.

The host of the White Lion was considered to be the prime source of news brought from foreign fields. To let the townspeople know that the latest news had arrived the landlord always had a canon ready and loaded. As soon as news arrived, it was brought out to the front entrance and discharged. By the time the townspeople had reacted to the signal and gathered, the town crier would be in place ready to impart the news, be it good or bad.

The White Lion sits on the corner of Great Underbank.

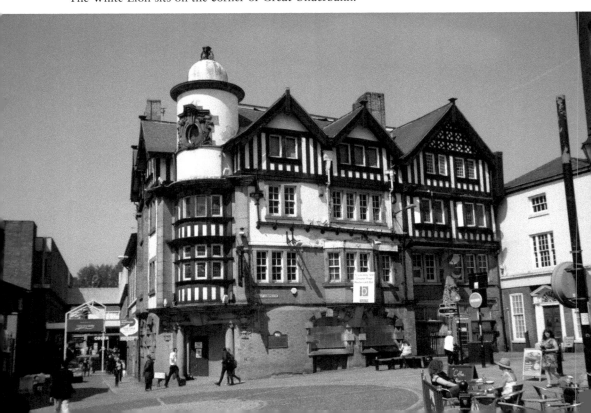

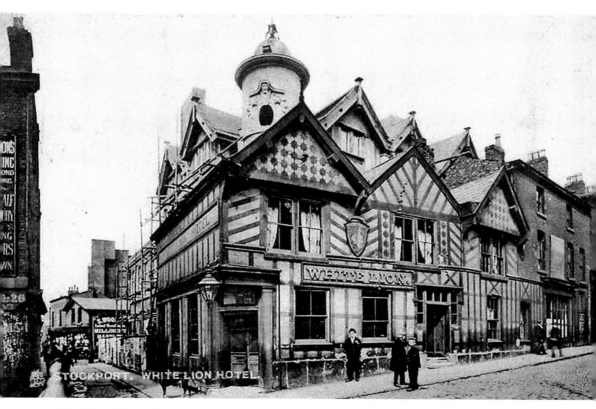

The White Lion before reconstruction in 1832.

Echoing the events of Thomas Hardy's *The Mayor of Casterbridge*, it is alleged that a 'wife sale' took place at the White Lion in 1831, during which a man called William Clayton sold his wife for 5s.

In its heyday, the White Lion was used for civic functions and banquets held by the area's nobility. It was also a meeting place for businessmen to agree on their transactions and for farmers to meet to fix prices on livestock before they were released onto the market.

19. Stockport Infirmary (Millennium House), 1834

Stockport Infirmary was the successor to Stockport Dispensary and House of Recovery, which was founded in 1872. The dispensary was opened to support a rapidly growing population as Stockport grew from a market town into a centre of industry.

Inoculation against smallpox featured high on the priorities of the dispensary. Patients were inoculated free of charge, but had to pay a deposit of 1s to guarantee

their reappearance for a second jab. As the dispensary's services grew, a need for surgical wards developed that could not be accommodated at its location close to Wellington Road Bridge.

A fund was opened to raise money for an infirmary in 1821, and the foundation stone was laid by Mayor J. K. Winterbottom on 18 June 1832. The transfer of medicines and staff took place in May 1834.

More fundraising took place after its opening. In 1837, one of the empty wards was furnished by the ladies of Stockport and named the Victoria Ward to celebrate the coronation of Queen Victoria. Their efforts eventually led to the complete furnishing of the interior of the infirmary, the fitting up of consulting rooms and a supply of surgical instruments. Further funds were provided to place a clock in front of the building for £65.

The Cotton Famine, which caused the demise of manufacturing in England and poverty in the town, put a severe strain on the infirmary's resources. Beds, along with provisions for outpatients, had to be severely restricted.

In 1897, a new north wing was commissioned to celebrate the diamond jubilee of Queen Victoria, further increasing the infirmary's medical capacity. By 1903 the use of X-ray apparatus was being extensively used in treatments, and a new X-ray department was constructed in the basement of the building. In 1914, the capacity of the wards increased from 88 to 105 to accommodate those sent home from combat in the First World War. In 1924, a pathology lab was opened along with an ultraviolet ray plant in June 1927. The infirmary continued to serve Stockport well after the Second World War, eventually closing in 1996 when all services were moved to Stepping Hill.

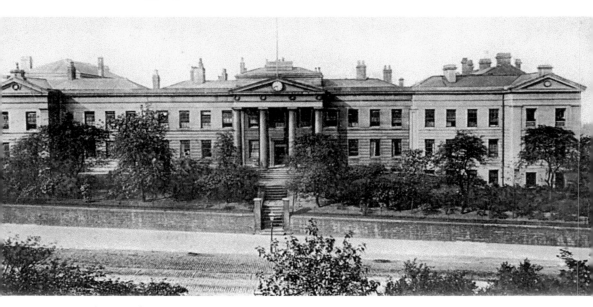

Stockport Infirmary, c. 1900.

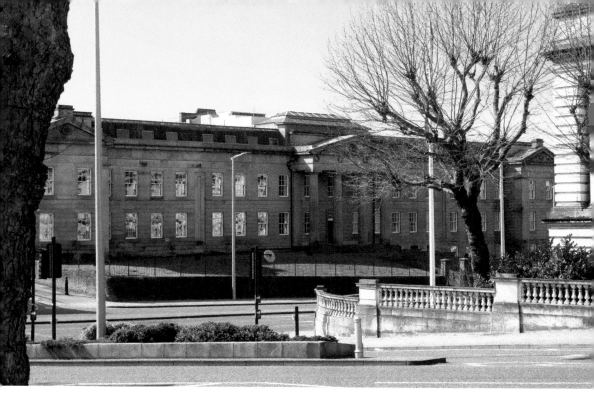

Today, Millennium House sits opposite Stockport Town Hall.

2C. Robinsons Brewery, 1838

Based in the heart of Stockport for the best part of 200 years, Robinsons is one of the oldest and most respected names in British brewing. It is a part of Stockport's historic skyline, with its elevated position making it visible from most parts of the town.

The beginnings of the brewery can be traced back to the Unicorn public house, which once sat on the land where the brewery now stands on Lower Hillgate. The landlord was William Robinson (a cotton overlooker from Bollington). After twelve years as the landlord, he purchased the inn from Samuel Hole on 29 September 1838. By 1847, William had left the Unicorn and moved to Heaton Norris, leaving his son George to run the pub with his wife and sister-in-law. George took the opportunity to indulge in his own brewing and produced the first Robinsons ale.

William's younger son, Frederic, took over from George in 1859 and expanded the premises by building a warehouse behind the pub. Brewing capacity increased and Robinsons ale began to be distributed around pubs in Stockport. To control the quality of the beer, Frederic bought several public houses in the town between 1878 and his death in 1890. The twelve pubs he purchased were the beginning of the family-run estate, which now owns more than 280 pubs across the North West and Wales.

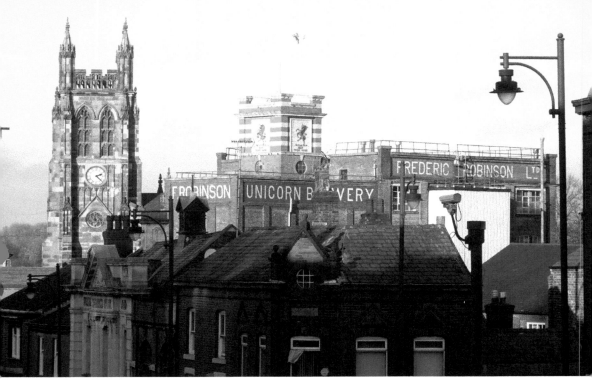

Above: Robinsons Brewery dominates the skyline from Middle Hillgate.

Below: The new visitors' centre tells the history of the brewery.

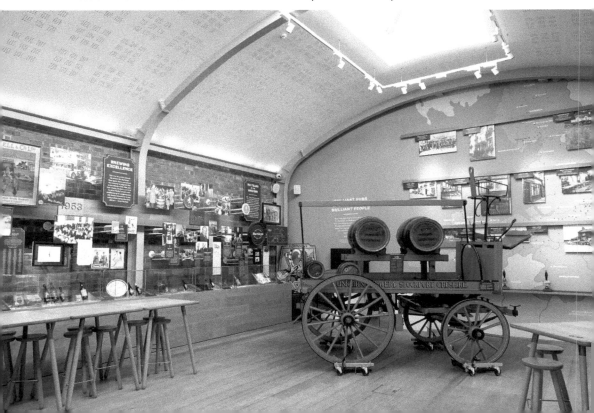

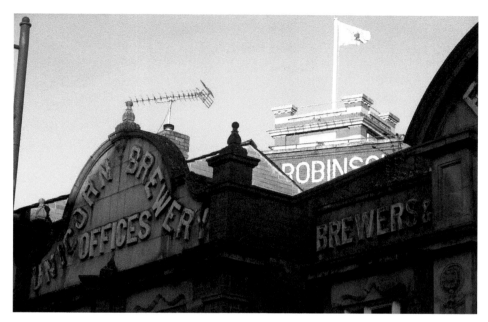

The old entrance to the brewery on Underbank.

Some of the original recipes are still in use today. Old Tom (first brewed in 1899) and Unicorn (first brewed in 1896) are longstanding favourites.

The brewery has a strong sense of tradition and even maintains its shire horses, which are used for special occasions. The horses have served Robinsons Brewery for over 100 years, except for the period covering the First World War when all horses were commandeered for war duties.

Robinsons now incorporates a successful visitors' centre where the public can spend an hour touring the brewing facilities, sample a range of beers, take lunch in the on-site restaurant and buy beers and souvenirs from the gift shop.

At the time of writing there are plans to move the brewery from the town centre and relocate the business to its packaging centre in Bredbury.

21. Stockport Railway Viaduct, 1840

Stockport Viaduct is the largest brick structure in the United Kingdom. It carries the main line from Manchester to London and was designed by George Watson Buck for the Manchester & Birmingham Railway. It was completed in 1840 and opened to rail traffic in 1842. At the time of its construction it was the largest viaduct in the world, rising approximately 33.85 meters above the River Mersey. It was a major feat of Victorian engineering.

The viaduct consists of twenty-seven arches and took twenty-one months to build at a cost of £70,000 (around £7 million in today's money). When it was

opened on 4 June 1840, it was referred to as Edgeley Viaduct, in keeping with the name allocated to Stockport's station. At the height of its construction 600 workers were employed in shifts working around the clock to complete the structure. It was built using only layers of common brick – an estimated 11 million in all.

The Stockport Viaduct was the scene of a rail accident on 30 November 1948 at approx 7.40 p.m. In the darkness and thick fog a combined Buxton service ran into the back of a combined Crewe and Disley service that was stopped at the signal at the south of the viaduct waiting for a platform.

Although the collision happened at a relatively low speed (only 10–15 mph), the last coach of the Crewe/Disley service telescoped into the forward carriage, and five people lost their lives. The impact point was almost exactly in the centre of the viaduct. The cause of the accident was attributed to a misinterpretation of vocal signals given to the driver of the Buxton train, which had stopped just south of Heaton Norris station. The driver mistook the shout from the assistant porter as one from the guard and thought it was an instruction to proceed. However, no permission was granted from the signal box, which would have allowed a train to proceed in dense fog if the signals were not visible.

The viaduct has appeared in several of L. S. Lowry's works and has made a brief contribution to literature, being mentioned in the introduction to the northern mill towns in Elizabeth Gaskell's *North and South*.

The viaduct and M60 motorway at night.

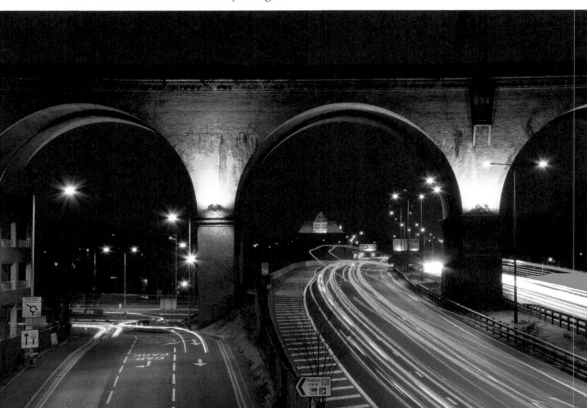

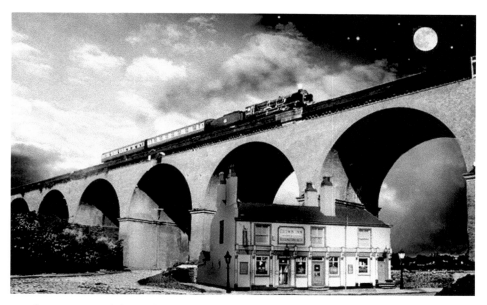

My fine art print of the viaduct and Crown Inn.

22. Christ Church, Heaton Norris, 1846

At the southern end of Wellington Road North in Heaton Norris is Christ Church, completed in 1846 on land donated by Wilbraham Edgerton of Tatton Park. Like St Thomas' Church on Higher Hillgate, it is a 'Waterloo' or 'Commissioners Church', built to celebrate the country's success in defeating Napoleon.

The church was designed by Manchester architect William Hayley. It is an excellent example of Victorian Gothic design and is constructed in yellow sandstone with a Welsh slate roof. The tower is in four stages and has a tall, slender spire with a distinct twist when viewed from the appropriate angle. On the west side of the lowest stage is a portal, and above this in the next stage is a west window with plate tracery. On the north and south sides of this stage are paired lancet windows. In the third stage are circular openings that formerly housed the clock faces, and in the top stage are paired bell openings. On the summit is a pierced parapet with tall pinnacles at the corners and smaller intermediate pinnacles.

The church was in regular use up to the 1970s, but around this time it was discovered that the fabric of the building was in very poor condition, including a considerable amount of dry rot, and worse was to come. In 1977, it had the misfortune to catch fire during the firemen's lengthy industrial dispute. By the time the fire could be tackled considerable damage had been done to the structure, and the fate of the building was all but sealed. Following the fire, much of the church was demolished apart from the tower, spire and parts of the adjoining walls. Sadly, the five clock bells, made by Warner in 1896, were stolen in 1977. The church, however, remains one of English Heritage's Grade II* listed buildings.

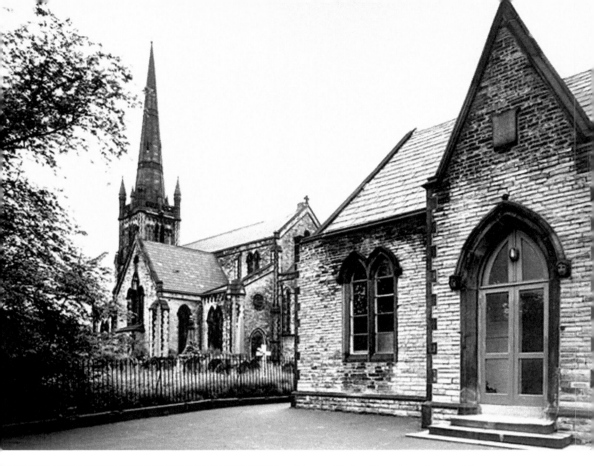

Above: Christ Church and school in 1975.

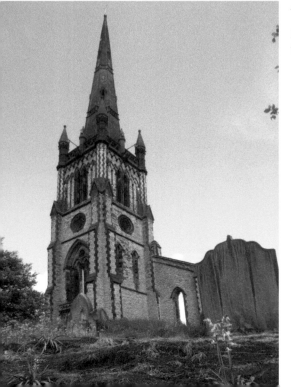

Left: The ruins of the church now dominate the Heaton Norris skyline.

23. Abney Hall, Cheadle, 1847

Abney Hall is a classic Victorian house situated in parkland just off Wilmslow Road in Cheadle. The hall dates back to 1847 and is a Grade II* listed building.

The foundations of the hall were laid in 1842 on a site previously occupied by Cheadle Grove Print Works, which had been destroyed by fire. The hall was completed in 1847 but underwent some remodelling in 1850 when it was under the ownership of Sir James Watts. The building was originally called the Grove and was the home of Alfred Orell, the Mayor of Stockport, who sadly died only a year after its completion. Sir James Watts was responsible for giving the hall its modern name, apparently naming it after Sir Thomas Abney who was a friend of Sir Isaac Watts for over thirty years.

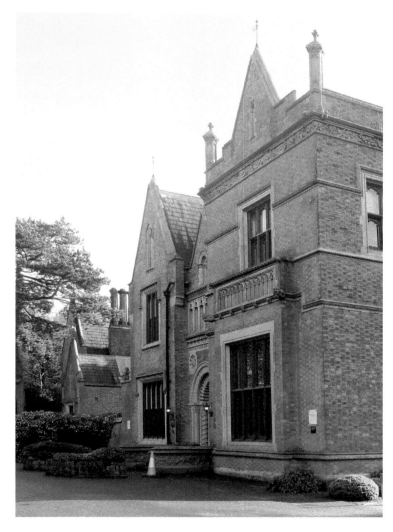

Abney Hall sits on grounds just off Wilmslow Road in Cheadle.

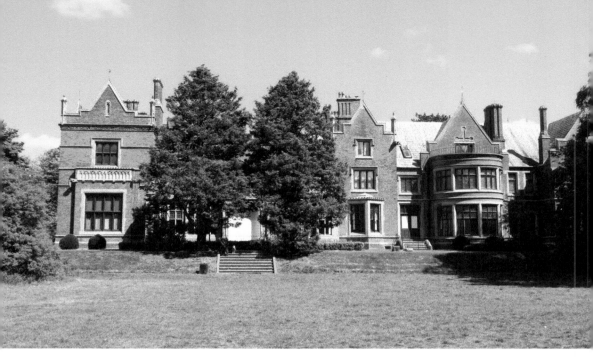

The rear of the hall faces onto lawns and woodland.

By 1857 Abney Hall was ready to accommodate Prince Albert, Queen Victoria's husband, during a two-day visit to Manchester, and was described as 'one of the most princely mansions in the neighbourhood'. Many famous people have stayed at Abney including King Edward VII, Victorian prime minister Benjamin Disraeli, English novelist E. M. Forster and Prime Minister Gladstone.

The last private owner of Abney Hall was the grandson of Sir James Watts (1804–78) who was also named James Watts. Sir James's grandson was Agatha Christie's brother-in-law. James married Agatha's sister, Margaret (Madge) Frary Miller (1879–1950) in 1902. Agatha often visited the hall and wrote two stories while there: the novel *After the Funeral* and the short story *The Adventure of the Christmas Pudding*, which is part of a collection of short stories of the same name.

Agatha also used the setting of Abney Hall on which to base Chimneys, a country house and seat of the fictional Marquesses of Caterham in *The Secret of Chimneys* and *The Seven Dials Mystery*. Several references to locations around Cheadle can be found in her books and it was believed that Abney became Agatha's greatest inspiration for country house life.

24. Stockport Armoury, 1862

Stockport Armoury sits at the top of Greek Street overlooking the maze of tracks that lead into Stockport station. The Grade II* listed building consists mainly of

an octagonal tower in red brick with pointed copper and ashlar rusticated quoins and cornice. It was opened on 22 April 1862 with a bazaar attended by Mr and Mrs Gladstone. The *Stockport Advertiser* commented, 'The assembly was of the most recherche description and comprised the elite and the bon ton of the Borough and its suburbs.'

The building was extensively used over the next sixty years. It housed the Cheshire Regiment in 1883 and the 6th Battalion in 1908. The battalion was mobilised at the drill hall in August 1914 before being deployed to the Western Front before being disbanded in 1920.

After the war, it continued to be home to several regiments. One of its units that saw the most active service was the 81st Heavy Anti-Aircraft Regiment, Royal Artillery, which saw service in the Blitz, in the Orkney and Shetland Defences and in the Middle East during the Second World War. Since 1969, the armoury has been home to several volunteer battalions.

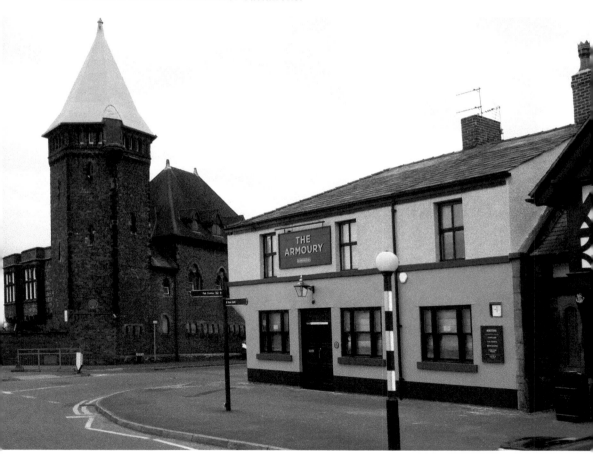

The armoury next to the pub of the same name.

25. St Petersgate Bridge, 1864

The Roman road from Manchester to Buxton crossed the Mersey at Stockport. Originally, this would have been just a ford, but by medieval times it had been replaced with a bridge and the routes in and out of the town were established. The western entrances to the town were defined by Chestergate, which connected Stockport to its county town and St Petersgate, which directed travellers across the town on an elevated route towards St Mary's Church and Stockport Market Place.

In 1860, Stockport Council authorised the construction of a glazed and cast-iron covered market in the Market Place. However, high-level access to the Market Place from the western approach was restricted by Little Underbank, which sat in the natural ravine of Tin Brook.

In 1864, it was decided to construct a bridge over Little Underbank, linking the Market Place with St Petersgate to secure an easier approach from the west of the town, particularly for those arriving at Edgeley railway station. The construction was technically challenging, given the nature of its urban location, but it proved to be a significant addition to the transport infrastructure of mid-nineteenth-century Stockport.

St Petersgate Bridge was designed by architect R. Rawlinson and constructed by Brierley of Blackburn. The cost was around £6,000. The bridge, now Grade II*

The bridge carries St Petersgate high above the town.

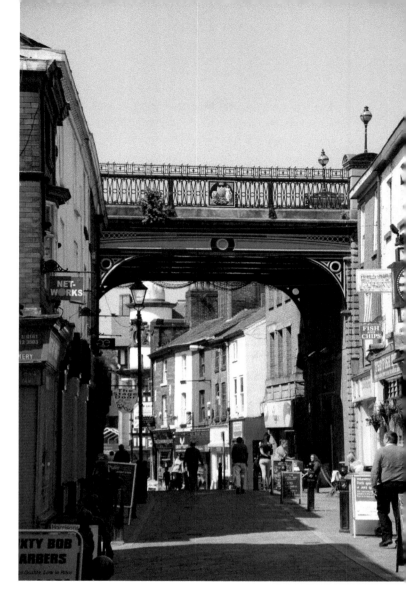

The bridge towers above the shops and pubs of Underbank.

listed, has some interesting features, including five cast-iron arches, cast-iron signs with pointing hands and relief lettering and a plaque bearing the borough's coat of arms. The design of the bridge won public approval. Its ornamental features signified a move away from bridges, which were often seen by the public to be an eyesore and offensive to public taste.

Turner's Vaults, which is built into the arch on the south side of Little Underbank, had occupied the site since the late eighteenth century. The premises were demolished and rebuilt into the bridge shortly after construction was completed. The owners dealt in wine and spirits and ran the Queen's Head, which is situated next door, separated from the bridge by the steps that ascend to St Petersgate.

26. Barnes Hospital, Cheadle, 1875

The Barnes Hospital building sits just off Kingsway to the south of the M60. The hospital was planned as a convalescent home annexed to the Manchester Royal Infirmary. It was designed by architect Lawrence Booth and constructed between 1871 and 1875.

Work was completed in 1875 and the hospital contained 132 beds. During its construction the broken remains of three high stone Celtic crosses were discovered by the builders, although only one of these has survived. It is located in St Mary's Church, Cheadle, and is thought to date from the tenth or eleventh centuries. The building's main landmark is the tall clock tower that was constructed with clock faces on each of its four sides.

The hospital was not a commercial success and lost thousands of pounds every year. During this period it was subsidised by Manchester Royal Infirmary. The trustees of the infirmary eventually managed to install more beds, which led to greater profitability. Electricity and mains water were installed in 1925 and specialist departments were introduced, including an orthopaedic ward. Eventually, other improvements followed including the installation of lifts, the opening of a surgical theatre, an X-ray department, a physiotherapy gym and an occupational therapy department. With the increase in expertise, the hospital was able to offer longer-term care to many more patients.

Barnes Hospital's interior some years after closing.

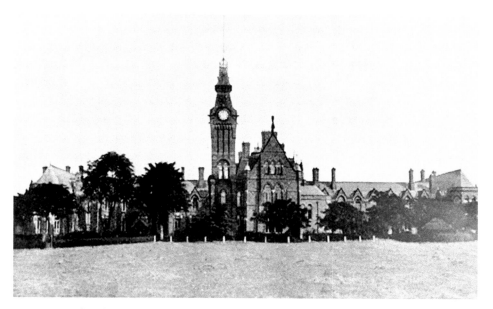

Barnes in its heyday as a hospital.

During the First World War the hospital served as a convalescent home for soldiers returning from the front, complementing the two smaller hospitals run by the Red Cross that operated in nearby Heaton Mersey and Heaton Moor. There was also provision for treating patients with tuberculosis and yellow fever in its isolation wards.

The hospital finally closed in 1999, but throughout its years of operation treated tens of thousands of patients successfully. In the same year, the hospital received its Grade II* listed status. Despite offers to buy the buildings and land, the site fell into a state of dereliction. Today the original building and its land have been sold and redeveloped to provide a variety of new homes set in a landscaped environment.

27. Houldsworth Mill, Reddish, 1865

Houldsworth Mill, or Reddish Mill as it was originally known, is one of the town's surviving cotton mills. It was built for Sir William Houldsworth at the height of the cotton production boom in north-west England. When the mill opened in 1865 it was the largest cotton-spinning mill in the world, employing 454 workers and covering 64 acres of land.

William Henry Houldsworth was the son of one of the region's wealthiest industrial families and Conservative MP for Manchester North West from 1883 to 1906. Such was his stature, he was made a baronet in 1887 and the main town square in Reddish was named after him.

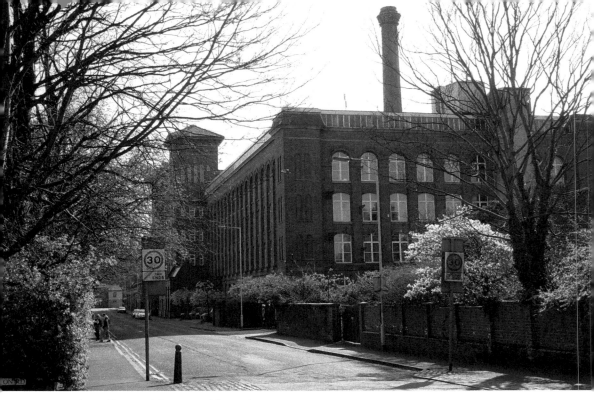

The mill viewed from Houldsworth Street.

Cotton production ceased at Reddish Mill in the 1950s. The name was changed and the mill was sold to a mail-order catalogue company, John Myers, for use principally as a warehouse up to the 1970s when mail-order trading ceased.

The mill is distinguished by its 110-foot-tall octagonal chimney, set on a plinth that dominates the local skyline. The building has retained much of its Victorian character including its grand double frontage. Today it is a fine example of how industrial heritage can be preserved by adapting a building to twenty-first-century needs with managed workspaces, conference suites, virtual office space and co-working environments.

28. Reddish Vale Railway Viaduct, 1875

Reddish Vale Country Park offers a pleasant escape from the busy suburban environment that surrounds it, and its long history supports tales of farming, milling, textile manufacturing and quarrying. Take a walk in its green and pleasant surroundings and you enter a world that has been shaped over centuries and contains reminders of the part it has played in the lives of ordinary people. Sadly, some of the buildings, such as River View Cottages, are no longer there. Similarly, the nine houses that stood under the railway viaduct were pulled down in 1914 despite offering a service to local walkers who were sold refreshments by their enterprising inhabitants.

In 1867, the Manchester, Sheffield & Lincolnshire Railway and the Midland Railway formed the Sheffield & Midland Railway Companies' Committee, with a brief to eventually establish a line into Manchester from London via Ambergate and Millers Dale in Derbyshire. By 1875 a direct line was planned through Strines, Marple, Bredbury, Brinnington, Reddish (Reddish North), Ryder Brow and Belle Vue.

The line had to cross Reddish Vale and stretch across the River Tame. To accomplish this, the line was carried on a viaduct comprised of sixteen semicircular brick arches mounted on brick piers, the central pier being larger in section. The imposts supporting the arches were constructed of stone. Officially known as the Tame Viaduct, it is better known by its colloquial name of 'Sixteen Arches'. The viaduct drastically changed the outlook of the valley, and it is said that a local witch who was unhappy with it being built put a curse on anyone who dared count the arches.

The viaduct gained royal ascent in 1905 when the LNWR royal train (only two years old) crossed the viaduct with Edward VII and Queen Alexandra on board. Their crossing of the viaduct was undertaken because every year two provincial cities were favoured with a state visit, and Sheffield and Manchester were the choices for that particular year.

An aerial view of Reddish Vale and the viaduct.

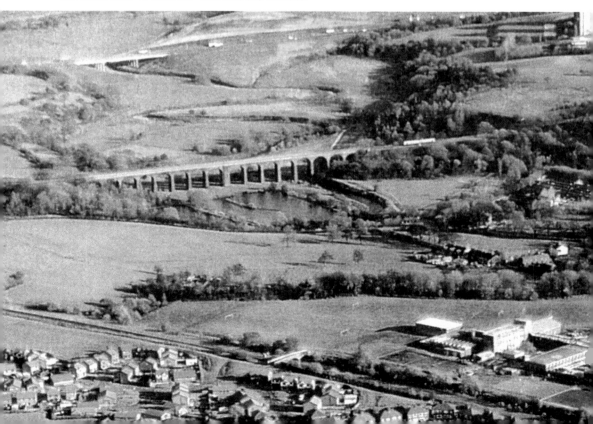

29. London & North Western Goods Warehouse, 1877

The London & North Western Railway (LNWR) was formed on 16 July 1846 by the amalgamation of the Grand Junction Railway, London & Birmingham Railway and the Manchester & Birmingham Railway, which was the company responsible for the construction of Stockport Viaduct and Edgeley station.

This substantial warehouse sits just north of the A6 and would originally have been annexed to Heaton Norris railway station. The present building was constructed in 1877 and replaced a smaller storage building on the site, which was destroyed by fire. It is distinguished by the lettering, 'London and North Western Railway Company's Goods Warehouse', which runs along the top of the building facing the main line railway.

The warehouse had a substantial capacity and goods wagons were shunted into the building through two of the seven large openings at its southern end. Within the building, all tracks were linked by turntables to facilitate the movement of wagons and goods.

The decision to grant Grade II* listed status to the building was taken because of its prominence as a large and impressive later nineteenth-century goods warehouse designed to promote the standing of the private railway company that built it.

The warehouse sits alongside the main Manchester to Stockport railway line.

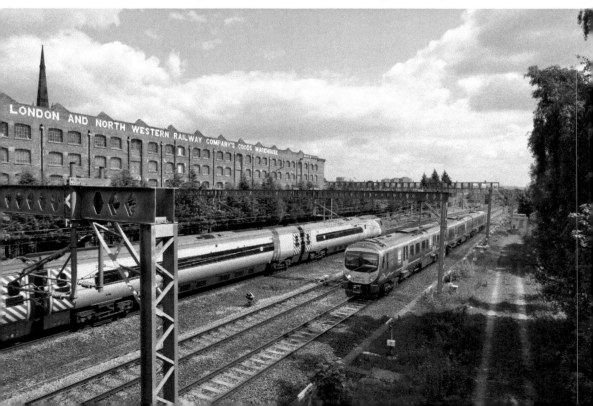

30. Winter's Jewellers Building, Little Underbank, 1880

It could be argued that in the nineteenth century Little Underbank was probably the finest shopping street in Stockport. Residents and visitors could access a range of shops, including hosiers, milliners and curriers.

One of its most iconic buildings is the former premises of Winter's Jewellers. In 1880, Jacob Winter decided to move his business from Hillgate to a more central position in one of Stockport's most prestigious shopping areas.

Security was always going to be an issue for a jeweller and the premises along the eastern side of Little Underbank had no rear entrances as they were built into solid rock.

The fact that you could only enter Winter's through the front required Joseph to install a unique security system. His ingenuity was such that by harnessing the power of natural spring water he made a device for lowering and raising the window display, which could be moved hydraulically into the basement for safekeeping.

Although the premises has passed through several owners in recent years, the upper storeys still retain the famous clock and the Victorian figures of a sailor and soldier. They stand on each side of a figure of Father Time sporting his white beard and holding the traditional scythe.

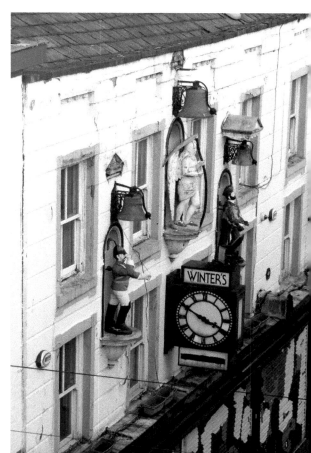

Winter's viewed from Petersgate Bridge.

31. Stockport Market Hall, 1861

The Market Hall is architecturally one of the area's most interesting buildings. One of Stockport's best-known landmarks, it used to be known as 'the Glass Umbrella', as its wrought- and cast-iron framework was originally an open-sided building with a glazed roof.

A market has been held in Stockport for over 700 years since a charter was granted in 1260 by Prince Edward, the Earl of Chester. Who later became Edward I. The site of the present market is probably set on the outer defensive enclosure of Stockport Castle, which stood on the present site of Castle Yard. The original market stalls were most likely situated in the narrow streets of the town itself, which developed on the ground beneath the castle, near the River Mersey.

With the military functions of the castle coming to a close, the market moved into the area in which it is situated today. At first, the area was divided into building plots some 10 meters wide, but as demand from traders increased the old plots were subdivided into smaller sections.

As the town grew, the weekly markets began to thrive, with traders being attracted from Poynton and Manchester. Stockport was a typical country market selling livestock, fruit, grain and bread. It would have been particularly busy on market days, which accounts for the many public houses surrounding the square and those located a short distance away in the town

Stockport Market Hall viewed from Churchgate.

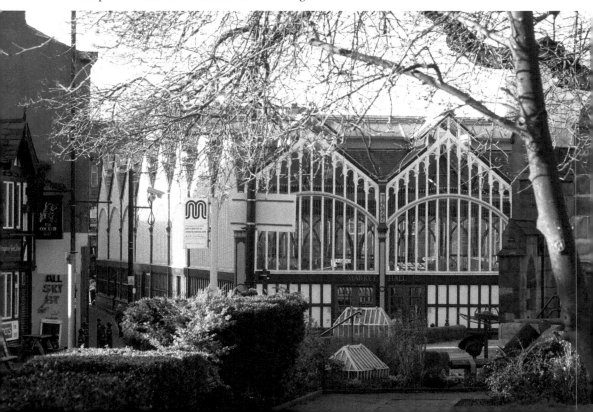

Right: The market now hosts a new range of stalls.

Below: The wrought-iron structure is a feature of the Market Hall.

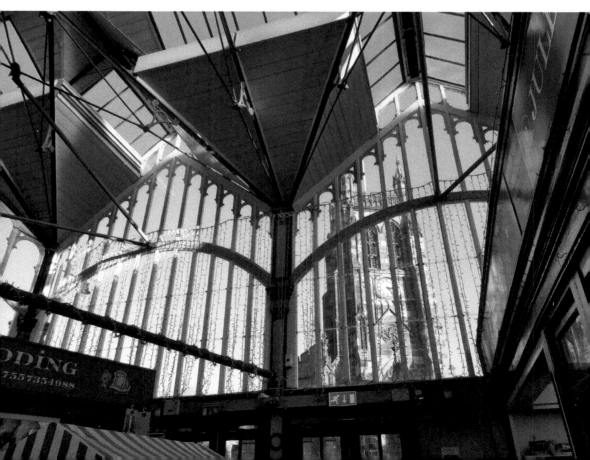

At the time of the Market Hall's construction in 1861, Victorian designers were embracing new architectural possibilities created by using iron. Increased floor spans were made possible by using wrought-iron joists, which could span greater distances than timber ones. The strength of cast-iron columns allowed larger openings in the external walls, which was a feature of Stockport's new Market Hall with its completely open sides.

Today, stalls selling a variety of goods can be found in the Victorian covered Market Hall. It is one of the few remaining traditional street markets in the North West, and a Grade II* listed building that dates back to 1861.

32. St George's Church, 1897

St George's Church on the A6 in Heavily is one of Stockport's true landmarks and can be seen from most approaches to the town. It was constructed between 1893 and 1897 and was consecrated on 25 February in its year of completion. It is a Grade I* listed building.

The church was built from Runcorn sandstone formed from deserts that covered the area 250 million years ago. The architect was Hubert Austin of Lancaster and

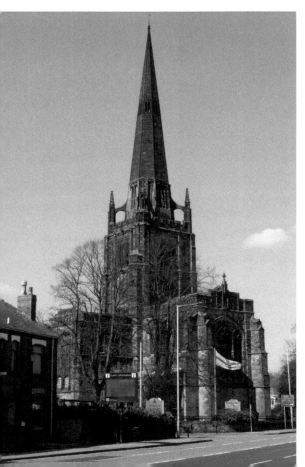

St George's Church is one of the town's most famous landmarks.

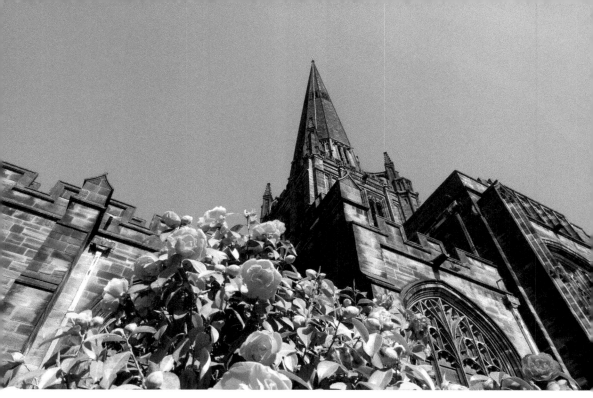

The spire of the church is 236 feet tall.

it is built in the Gothic Revival style. Major George Fearn JP provided the finance for the church and the adjacent schools and vicarage. He was a local brewer and lies in the cemetery opposite. His grave is distinguished by a miniature replica of St George's Church tower and spire.

The church is of considerable size, measuring 180 feet long and 75 feet wide. The tower is 112 feet high and the tower and spire together are 236 feet. It was designed to accommodate 1,450 worshipers and, even today, given the modern constraints of the area inside, it has a seating capacity of around 1,200.

One of the centrepieces of the church is its organ. It was originally built and installed in February 1897 by Forster and Andrews of Hull. In 1935, it was rebuilt and enlarged by the John Compton Organ Company and, apart from regular cleaning and maintenance, has remained largely unaltered since.

Inside the church, the reredos is made from Derbyshire alabaster, as is the font. The lectern consists of a brass eagle standing on a pedestal supported by lions. The Lady chapel is separated from the chancel by a carved oak screen and contains an oak reredos that includes the figures of St John the Divine and St John the Baptist. There is stained glass only in the east and west windows, with the eastern window depicting St George and the dragon. The churchyard is a sandstone memorial to the First World War dating from around 1920. It includes panels inscribed with the names of 137 men, a tall cross, and a statue of St George standing under a gabled canopy.

33. Nelstrop's Flour Mill, 1893

The Manchester to Ashton Canal was opened in 1796. Just a year later, Stockport was linked into the canal system by a new spur that ran from between locks 10 and 11 at Clayton, down into Heaton Norris at the top of Lancashire Hill.

The main purpose of the canal was transportation of coal from the collieries around Ashton into Stockport. In addition, it was used to carry general cargo such as raw cotton to the local mills, returning with manufactured goods. It also carried supplies of grain to William Nelstrop and Company's Albion Mill in Heaton Norris.

Nelstrop's is the only independent family miller in the north-west of England and Scotland. The company was founded in 1820 by nineteen-year-old William Nelstrop, who set up a corn-dealing business on Lancashire Hill where the Nelstrop mill stands today.

William took ownership of Albion Mills on Lancashire Hill a year after it was built. He became an important figure in local society and rose to the position of Mayor of Stockport. He was offered a knighthood by Queen Victoria for his part in defusing the anti-Corn Law riots in the 1840s. However, William refused the honour, partly because he had sympathy for the poor who were starving because they could not afford to buy bread, and partly because lower wheat prices would benefit his own business.

Nelstrop's Mill and the Navigation Inn.

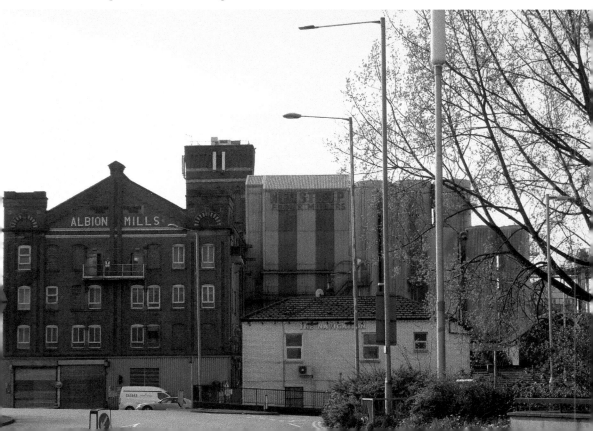

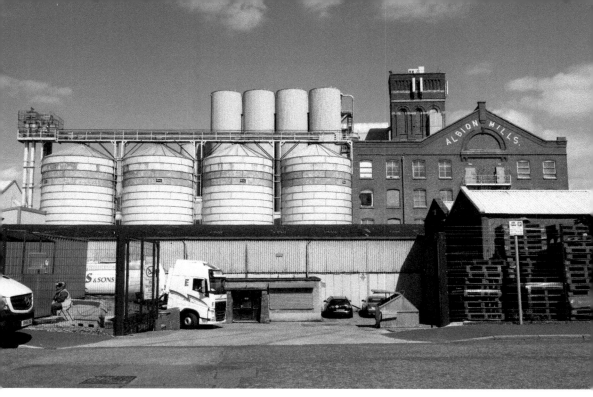

The flour silos dominate the rear of the mill.

The original mill was destroyed by fire in 1893, but William seized the opportunity to rebuild and replaced all but one of the stone grinding wheels with the newly developed Henry Simon steel roller mills.

During the Second World War, all the central Manchester flour mills were destroyed in air raids, but Nelstrop's responded admirably to support the war effort and kept families supplied with flour. The company introduced three shift work schedules while family members and staff stood by with sand buckets on the roof to douse incendiary bombs.

The site of the Albion Mills has some real historical significance. When recent excavations were undertaken to provide foundations for a new office block a large millstone was unearthed, providing evidence of a windmill that had stood on the site for centuries.

34. The Bakers Vaults, Late Nineteenth Century

The Bakers Vaults once had a life as a gin palace. Such establishments were popular in the eighteenth century and sold gin to be taken away or just enjoyed standing up – often in the street outside. They were hugely popular but thought to be rather vulgar, often fitted out at great expense and lit by gas lights.

Above: The Bakers Vaults is an iconic building in the Market Place.

Below: The interior features a fine traditional bar.

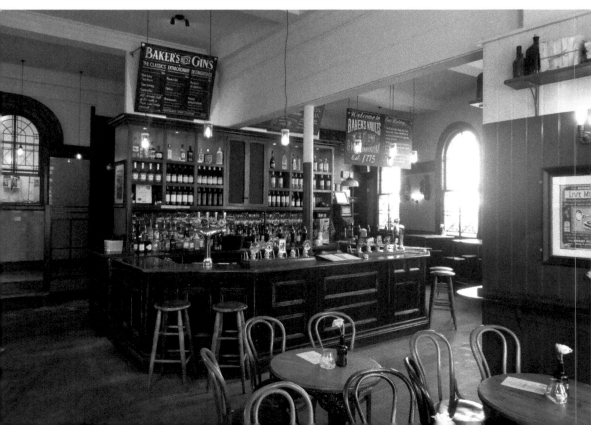

The first gin palaces were built in the late 1820s. The original building on the site was constructed around 1775 and called the George and Dragon. The George and Dragon was demolished in the late nineteenth century, and the Bakers Vaults were rebuilt in the gin palace style. It is an exceptional example of this type of construction. In its underground vaults remain the brick stalls designed to hold gin barrels.

It has many architectural features typical of the gin palace design. It contains a single large room, which is an architecturally impressive space and is of two-storey brick construction with arched windows and round-headed doorways with semicircular fanlights. In the middle bay is a pair of round-headed windows in a round-headed arch containing a laurel wreath. It is a Grade II* listed building.

Today the pub continues to host live music and entertainment as part of the vibrant scene of Stockport's market area.

35. The Garrick Theatre, 1901

The Stockport Garrick Theatre, situated on the corner of Exchange Street and Wellington Road South, is one of Stockport's gems. When the Dramatic Society of the Stockport Unitarian Church disbanded in 1901, local engineer Edwin Heys and some fellow members resolved to keep on the acting tradition of the town by forming a new society that they hoped would attract capable amateur actors and present plays to the highest possible standards. Based on this dream, an inaugural meeting in the Church Coffee Tavern on St Petersgate resulted in Stockport Garrick Theatre officially coming into existence on 24 October 1901.

It was resolved to name the theatre after David Garrick, one of the greatest actors of the day. The theatre has risen to its ambitious aims, producing a wide range of drama and musical performances for over 100 years. Indeed, as early as 1905 it was even experimenting with opera, undertaking an ambitious performance of *The Sorcerer*, a two-act comic tale by Gilbert and Sullivan. Challenging works by Ibsen and George Bernard Shaw featured in its seasonal programmes and, at a time when performances by such playwrights were considered risky, the Garrick was never afraid to push the boundaries.

To support the community, the theatre kept its doors open and curtains up throughout both world wars and attracted the admiration and support of numerous luminaries in the world of professional theatre, including theatre manager Annie Horniman, actor-manager Charles Charrington and his wife, actor Janet Achurch. On 10 May 2008, Sir Ian McKellen visited the theatre to unveil a plaque commemorating the theatre's foundation and its status as England's oldest little theatre. The plaque can be seen a short distance from the theatre on St Petersgate at the site of the coffee house where the original society was founded. A second plaque, on the same site, commemorates Sir Ian's visit.

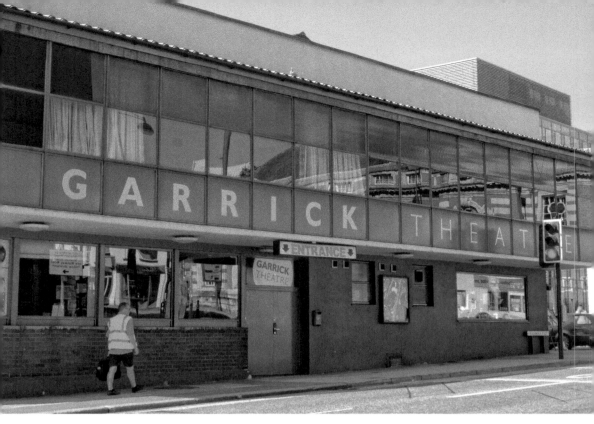

The fine glass and brick exterior of the Garrick.

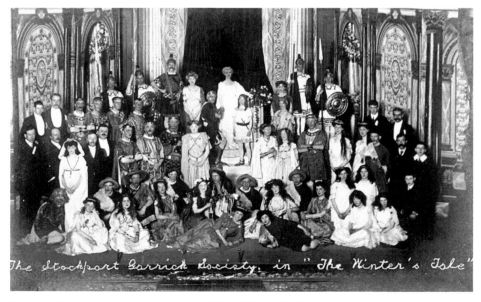

The cast from an early performance of *The Winter's Tale*.

36. Edgeley Park Football Stadium, 1901

Edgeley Stadium was built in 1901 for the rugby league club, Stockport. The football team did not arrive until 1903 when Stockport County moved to the ground from their previous home situated behind the Nursery pub in Heaton Norris. The first main stand was built in 1913. It held 500 spectators and was built from timber. A wooden terrace at the Cheadle End was built in 1923.

The current capacity of the ground is just under 11,000, which means the record attendance of 27,833 – set when Liverpool visited Edgeley Park to play Stockport County in the fifth round of the FA Cup in 1950 – is unlikely ever to be broken.

The ground has been home to some memorable football moments. It welcomed the first father and son ever to play together in the Football League when David and Alec Herd ran out for County in 1952. It jointly holds the record for the Football League's largest winning margin when Stockport crushed Halifax Town 13-0 on 6 January 1934 in the Third Division North.

In 1946, the ground witnessed the longest football match ever played. On 30 March 1946, Stockport County hosted Doncaster Rovers in the second leg of a League III North Cup match. The first game had finished 2-2, as did the second. So they played out extra time and, with no further goals having been scored continued, as the 'play to a finish' rule brought in during the Second World War was still in operation. As the match progressed, the players were collapsing with exhaustion, and the crowd was calling upon the referee to stop the game. Finally, in dusk and with a haze of smoke from the railway settling over the ground,

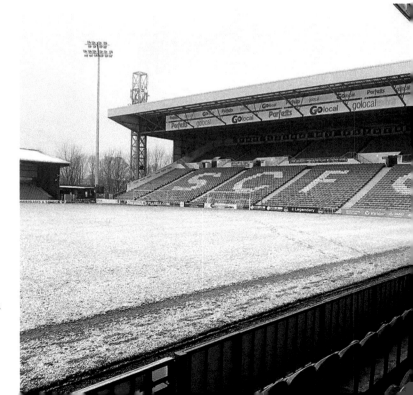

The Cheadle Stand was constructed in 1995.

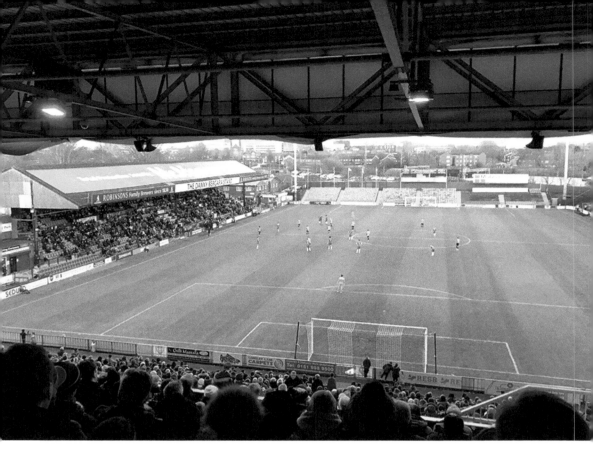

Matchday at Edgeley Park.

Mr Baker, the referee, decided that light was too bad to continue, and twenty-two weary players and three tired officials hobbled off the field.

After some years of uncertainty and private ownership, Edgeley Park passed into the ownership of Stockport Council on 31 July 2015. The ground is now rented back to the club on a commercial basis.

37. Broadstone Mill, Reddish, 1904–07

The centre of employment and cotton-spinning production for the north area of Stockport was Broadstone Mill, in Reddish, which stands imposingly on the southern sweep of Broadstone Road next to the dried-up beds of the old Stockport Canal.

It's a huge red-brick construction that dominates the skyline as you travel along Broadstone Road. When it was constructed, between 1904 and 1907, by Stott and Sons, it was the most modern mill in Europe. It comprised of two separate units joined by a central entrance building. The complex encompassed five floors,

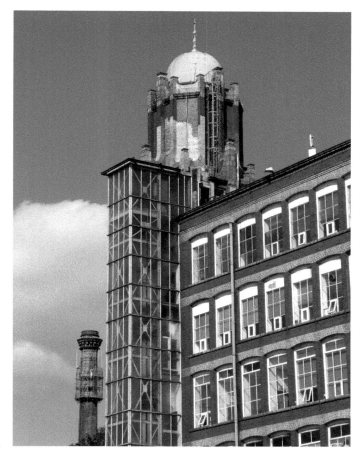

The copper cupola
of the mill still
dominates the skyline.

a basement and an ornamental water tower with a copper cupola. It covered an area of 640,000 square feet and when completed was the largest cotton-spinning mill in the world.

The Broadstone Spinning Co. Ltd, Reddish, was formed in 1903 with the intention of erecting a large double mill. Work commenced in 1906 and the two adjacent mills were quickly constructed. The building costs amounted to £480,000 by the time each mill was fully equipped (around £57 million today).

Each floor of the mill had a designated purpose. The basement contained the waste-disposal area, conditioning cellar, packing room, cotton, mixing room and dust cellar. The ground floor housed the card shed and blowing room. The next four floors were spinning rooms and the tower contained the staircase, hoist and toilets. Power was provided by George and Saxon steam engines and each of the individual mills had its own boiler house. The machinery for both mills was supplied by John Hetherington & Co. Ltd. The first mill had mules with 125,000 spindles and the second mill held 140,000 spindles, giving a total of 265,000 for the two mills.

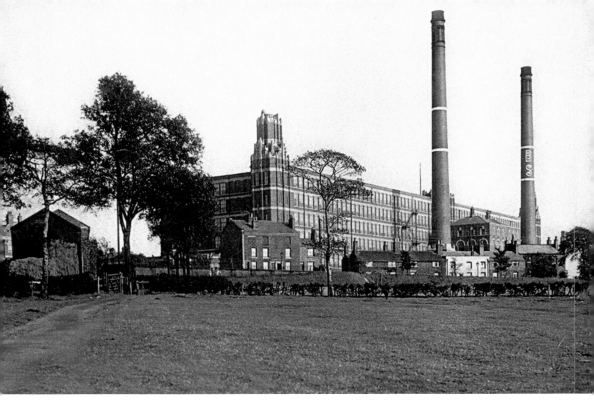

The mill in its heyday, *c.* 1930.

By 1941 many male workers had left the industry to fight in the Second World War and one of the mills was forced to close. It reopened for a short time in 1946 but by 1952 the cotton industry had started to decline and the workforce faced an uncertain future, with the mills finally closing in 1957.

38. The Almshouses, Heaton Norris, 1907

James Ainsworth of Heaton Norris left provision in his will for these twelve semi-detached cottages with gardens and stone entrance archway to be built on Green Lane in 1907. James was a wealthy local businessman who wished to provide accommodation for some of the neediest and most deserving residents of the Heatons. The bequest in his will stated that they were to be allocated to old people 'whose honourable record and needy circumstances make such shelter and assistance in their declining years well-deserved'.

Each property was designed to have a garden at the rear so that residents could focus industriously on growing vegetables as part of a regime to keep them active. The Grade II* listed buildings were built by Pierce and Son in 1907, and the red-and-grey brick design with red terracotta dressings is very distinctive. There are twelve properties, with both end houses having corner turrets with lead domes. Their design

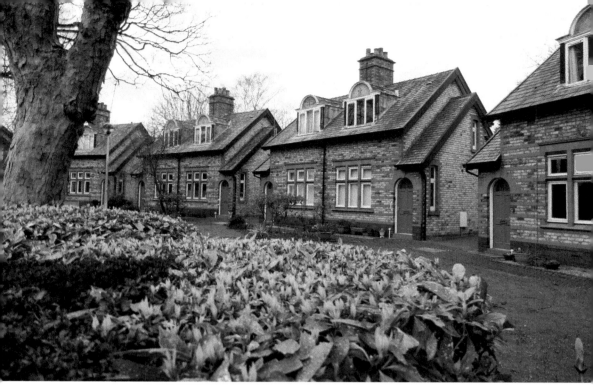

The almshouses on Green Lane.

is ingenious and compact. Each cottage has a small entrance hall, a scullery, a parlour, a kitchen, a privy (toilet) and coal storage. The first residents moved in around 1907 and the homes have continued to be allocated to retired people ever since.

39. Stockport Town Hall, 1908

Travelling south down Wellington Road towards the River Mersey, your eye is inevitably drawn to the white building with its imposing clock tower that dominates the road as it sweeps down towards the centre of the town.

Stockport Town Hall was designed by Sir Alfred Brumwell Thomas and was opened by the Prince and Princess of Wales in July 1908. To commemorate the royal visit, part of Heaton Lane, a main shopping street in the town, was renamed Prince's Street. The white limestone façade and tiered clock tower, which rises 130 feet above the pavement and is nicknamed 'the Wedding Cake', is a Renaissance-style building and was Grade II* listed in September 2007.

The magnificent interior includes stained glass, a marble staircase and wood carvings inspired by Grinling Gibbons. One of the chambers has elaborate plasterwork, decorative carvings on oak benches and brass chandeliers and, in the corridor outside the chamber, is the civic silver collection, some of which dates back to the fifteenth century.

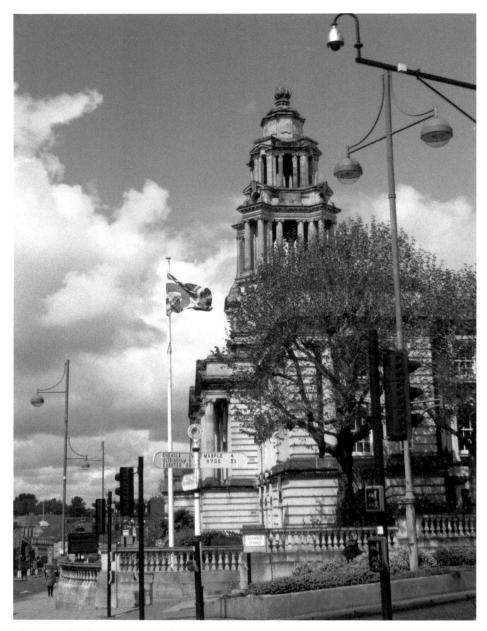

The Town Hall and old road sign giving directions to places near and far.

The Great Hall, or Edwardian ballroom, houses a Wurlitzer organ. The imposing Italian marble entrance leads through into this grand room, which former poet laureate Sir John Betjeman described as 'magnificent'. The Wurlitzer is one of just sixteen of its kind worldwide and is the only such model to leave

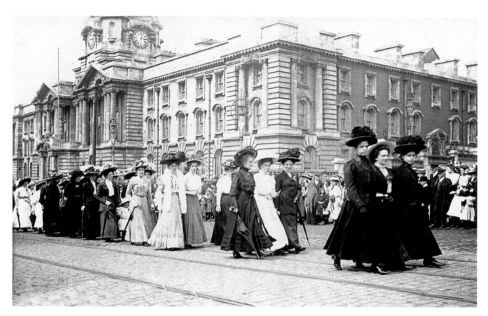

Above: Ladies
participating in the Whit
Walks, *c.* 1909.

Right: The Town Hall
building dominates the
rise of Wellington Road
South.

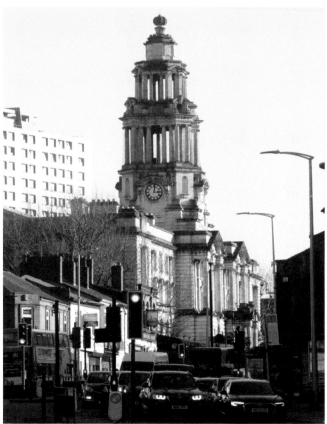

the United States. It was designed by American theatre organist Jesse Crawford and was originally purchased for the Paramount/Odeon cinema in Manchester in 1930. It is now owned by the Lancastrian Theatre Organ Trust, which obtained a grant to completely restore and rebuild the organ as near to its original condition as possible.

The Town Hall currently houses government and administrative functions. The Council Chamber displays have elaborate plasterwork, brass chandeliers and decorative carvings on oak benches.

The Town Hall is also the home of the Stockport Symphony Orchestra, who perform classical concerts on a regular basis.

40. Stockport Secondary School, 1909

The old Stockport Secondary School is a Grade II* listed building set back from Greek Street and sitting between the art gallery and Stockport College. It was built between 1909 and 1910 due to increased local demand for secondary education.

At the time it was built the school was adjacent to the technical school and Stockport Grammar School, which sat on the land now occupied by the art gallery. When it opened it was used mainly for the education of girls.

It was a well-equipped educational establishment that included a gymnasium (used by both boys and girls) in the basement. Classrooms on both the ground floor and the first floor were arranged about a centrally placed hall that contained a solid, oak-blocked floor and attractive mural panelling. A cantilevered balcony gave access to all the classrooms at the first-floor level as well as affording pupils a panoramic view of the spacious hall below. On the third floor were science laboratories, a spacious art room, kitchens and a modern dining room – deemed essential as the school's population came from areas as far away as east Cheshire.

However, the outbreak of the First World War in 1914 caused an unexpected change in the use of the school. As casualties on the Western Front began to rise, the War Office contacted all towns to require them to utilise buildings as emergency military hospitals. Among those nominated was the new Greek Street Girls' Secondary School, which became a hospital in May 1915.

In many boroughs, alternative accommodation for pupils was virtually impossible, and pupils found themselves being educated in any available buildings such as church halls and Sunday schools. The girls at Greek Street were fortunate in that tuition was satisfactorily provided in the technical school, which fortunately had been enlarged by 1915. It was not until 1919 that the Greek Street building reverted to its original function as the girls' section of the local secondary school.

In 1970, the school merged with the technical school, situated to its immediate east, which subsequently became Stockport College of Further and Higher Education.

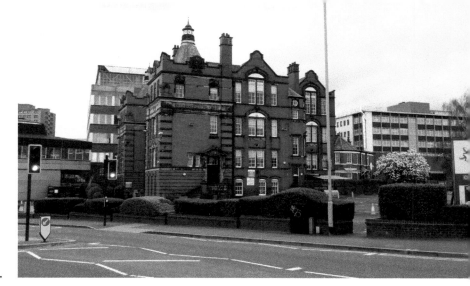

The secondary school building on Greek Street.

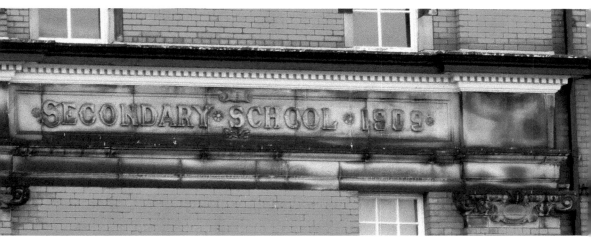

Above: The original school sign on the exterior of the building.

Right: The school *c.* 1900.

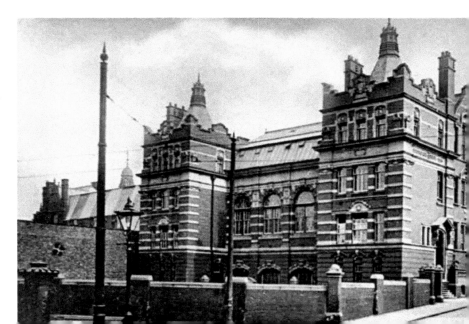

41. Stockport Central Library, 1913

Stockport Central Library is an imposing building of red brick and Portland stone. It is situated on the corner of St Petersagte and Wellington Road South. It was built between 1913 and 1915 at a final cost of £15,000. The wealthy American Andrew Carnegie covered the cost of the building.

He was born in Scotland and emigrated to America with his family in 1848. His father was a weaver and his mother was a shoemaker's daughter. He started work in a cotton mill and later found work as a telegraph operator on the American railroads. Recognising the rising demand for iron and steel, he founded his own company. Over the years he amassed a personal fortune of $480 million. He used some of his wealth to endow 2,509 libraries worldwide and 660 libraries in Britain.

The new library was opened in October 2013 by the mayor, Mr Thomas Kay JP. It had an immediate impact on the number of people from the town wishing to engage in reading. Its main attraction was the adoption of the safe-guarded, open-access system, which allowed readers to be admitted to the bookshelves to view

The impressive building sits on the corner of Wellington Road South and Petersgate.

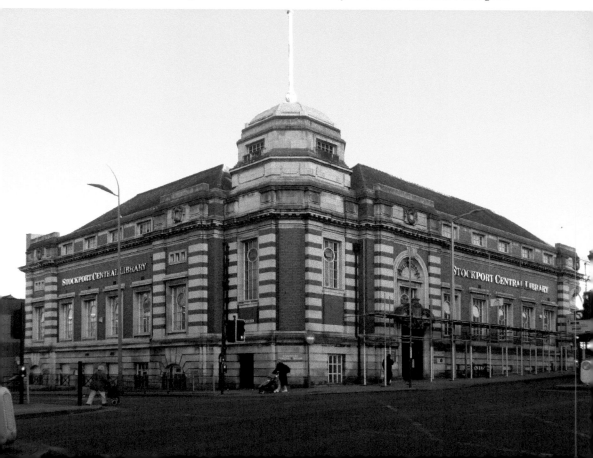

Stained-glass artwork is a feature of the library's interior.

and choose their books. The number of books borrowed rose from 1,500 in 1902 to 15,000 in 1922.

Another positive influence brought about by the new library allowed pupils from local schools access to study. Within the building, each elementary school had a small library ranging from 200 to 350 books. It drew praise from teachers who considered that the vocabulary of their children had increased along with a wider appreciation of reading. A reference section was later added as a result of a gift of money from the governors of the Ephraim Hallam Charity. The books were principally for the use of teachers and students studying for entry into the profession.

At the time of writing, plans are in progress to move Stockport's library services to Stockroom, a 47,000-square-foot town centre hub located in vacant retail units at Merseyway. The Central Library building on Wellington Road will begin a new phase in its existence by becoming the home of Stockport's adult education service.

42. The Savoy Cinema, Heaton Moor, 1923

The Savoy Cinema was opened by the Mayor of Stockport in March 1923. It had a balcony and seated over a thousand people. Audiences flocked to see its first

screening, a silent production of *The Virgin Queen* starring Lady Diana Manners with accompanying music from Constance Cross's Ladies Orchestra.

This new entertainment gave the people of the Heatons a view into worlds previously unknown to them and they would certainly have revelled in the action and drama surrounding the life of Elizabeth I. Diana Manners, later Diana Cooper, Viscountess Norwich, was a young socialite who, after working as a nurse during the First World War, turned to an acting career. She died at the age of ninety-three in 1986, having starred in silent movies, 'talkies' and some of the first colour films.

The Savoy was a state-of-the-art cinema and was even able to boast the use of Prizma Color, a system pioneered by William Van Doren Kelley and Charles Raleigh, which consisted of using different filters to add colour to various scenes in a black-and-white film. It was adapted for sound in 1930 and enjoyed huge success throughout the golden age of cinema. However, in 1938, the Savoy was badly damaged by fire and had to be closed for some months. With the coming of the Second World War, it provided much-needed light entertainment and screened regular newsreels from the conflict in Europe. It was also occasionally used as an evacuation centre for local families whose homes were under the threat of bomb damage.

After the war, the cinema managed to survive despite the coming of television and the associated drop in cinema audiences. In 1971, it underwent

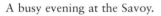

A busy evening at the Savoy.

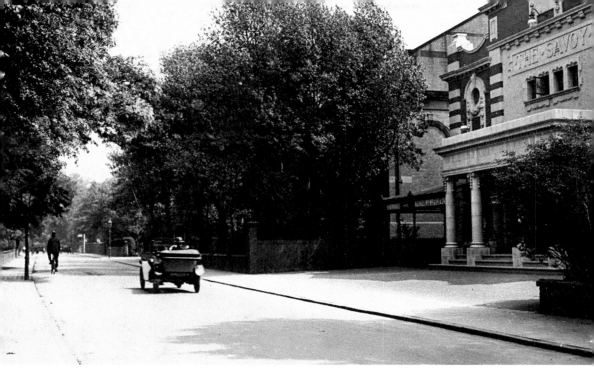

The Savoy just after opening, summer 1924.

a complete facelift, with its balcony being removed and the front boxed-in to provide a covered foyer and waiting area. At the time its advertising claimed it was the 'ultimate in luxury theatre-going' and it continued to provide a quality social amenity for Heatons' residents up until its closure in 2014. However, in 2015 an independent cinema group saved the Savoy from developers and undertook a programme of refurbishment that restored the cinema to its former glory.

43. Stockport Art Gallery and War Memorial, 1925

Stockport lost 2,200 men in the First World War (1914–18). On 9 September 1919, the mayor of the borough, Alderman Sir Thomas Rowbotham, presided over a meeting to discuss the possibility of erecting a permanent memorial in the town in their memory. It was decided that the memorial should take the form of a group of commemorative sculptures, a memorial hall and an art gallery. The trustees of Mr Samuel Kay donated the site at the junction of Wellington Road South and Greek Street.

On Saturday 15 September 1923, the foundation stone was laid by the then mayor, Alderman Charles Royal. Within the stone were placed coins, newspapers of the day and scrolls recording the gift of the site. It also contained the following inscription: 'In memory of the men of Stockport who fell in the Great

War (1914–1918).' Work commenced shortly afterwards and was completed in the autumn of 1925.

Prior to construction commencing, a temporary memorial was placed on the site. This was unveiled on Saturday 31 July 1921, a day that marked the fourth anniversary of the Battle of St Julien (Pilckem Ridge) in which the local 6th Territorial Battalion of the Cheshire Regiment fought. The Battle of Pilckem Ridge was the opening attack of the Third Battle of Ypres – later known as Passchendaele.

The 6th Battalion, the Cheshire Regiment, was a pre-war Territorial battalion that was recruited in the north Cheshire towns of Stockport, Hyde and Stalybridge, together with the Derbyshire town of Glossop. The majority of its part-time soldiers worked in the area's cotton mills and hat-making factories. One of the first Territorial battalions to see action in the First World War, it went

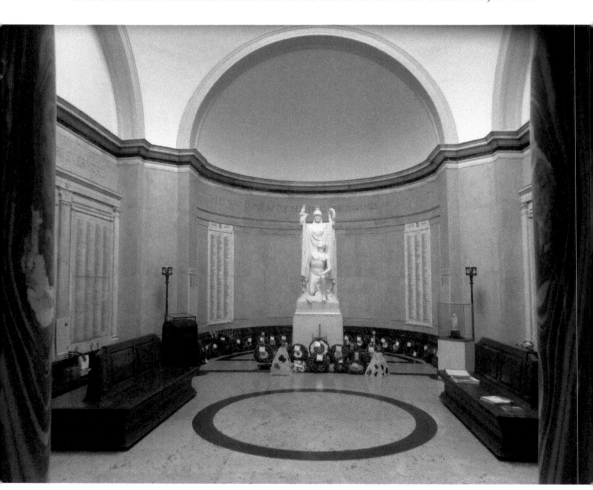

The Hall of Memory.

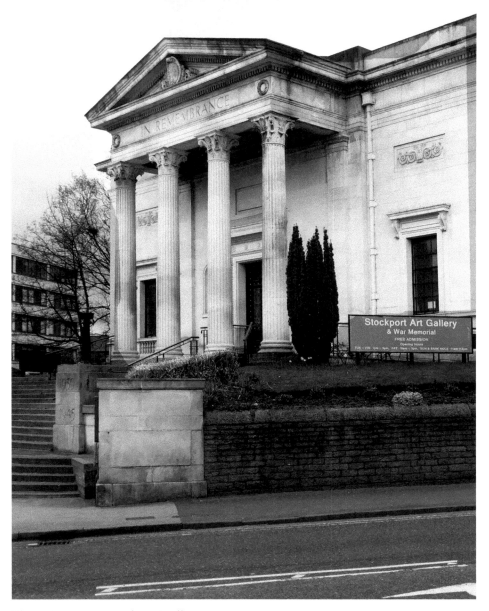

The main entrance to the art gallery.

overseas in November 1914, taking part in the famous Christmas truce a few weeks later.

Directly opposite the main entrance doorway is the Hall of Memory, which rises to the full height of the building and contains the group of sculpture permanently lit by a spotlight and daylight that falls through a stained-glass roof dome.

44. The Plaza Theatre, 1929

The Plaza was built in 1929 on the site of former cottages adjoining the Lawrence Street steps. To construct the theatre 10,000 tons of rock had to be excavated from the sandstone cliffs, which rose from the centre of the town.

The architect was William Thornley, who was well known in the Manchester area for designing around fifteen cinemas and theatres in the city.

The whole concept behind his design was to create a luxurious, uplifting and fantastic building to complement the dream-like experience of film entertainment and provide effective recreation for people accustomed to the hard life of a northern industrial town.

As a result of this, a building emerged with well-defined Egyptian, Moorish and art deco architectural influences. The opening show at the Plaza took place on Friday 7 October 1932 and featured the films *Jailbirds* starring Laurel and Hardy, and *Out of the Blue* with Gene Gerrard and Jessie Matthews, along with the resident organist Cecil Chadwick at the Mighty Compton Organ. Admission prices were 7*d* for the cheapest stall seats.

The opening of the Plaza was a huge success, generating profits of around £5,000 (the equivalent of around £315,000 today) in its first year. The cinema showed the first 3D film, *Sangaree*, in 1953 and broadened the scope

The Plaza at night viewed from Wellington Road North.

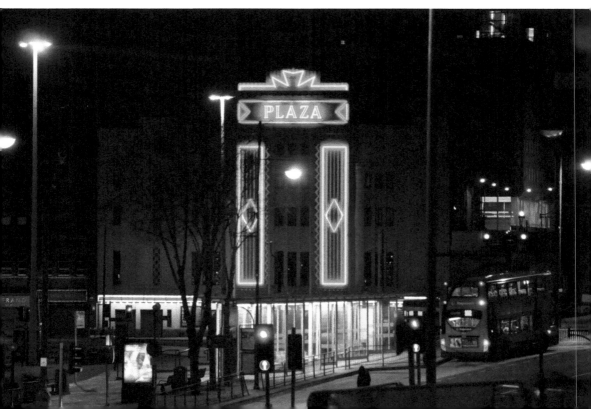

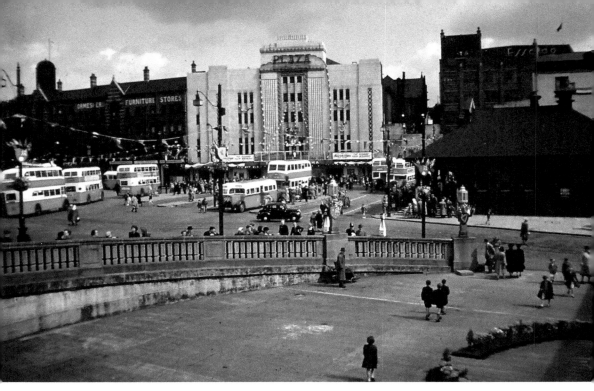

The Plaza on coronation day in 1953.

of its entertainment with live singers, organ recitals, skiffle groups and big band concerts in the 1950s. The Sunday jazz concerts were particularly successful and featured well-known performers like Johnny Dankworth and Cleo Laine.

In 1960, the Plaza was sold to the Mecca Group. It finally closed as a cinema in 1966 and was reopened as a bingo hall, which enjoyed huge success for many years, eventually closing on 23 August 1988.

In 2000, the Stockport Plaza Trust, a charitable trust formed to save, protect and operate the Plaza, reopened the venue with a dedicated team of volunteers and a few paid staff. In the following years they raised over £3 million for the first stage of the Plaza restoration. Today it is one of the finest variety theatres in the region.

45. The Regent Cinema, Marple, 1931

Marple's Regent Cinema is situated on Stockport Road on the east side of the town.

Thomas Carver and his family, who were strict Congregationalists, arrived in Marple in 1857. One of his first projects was to build the Union Rooms on Stockport Road, which were completed in 1878. Carver died in 1920, but the

rooms continued to survive for another twenty years until dwindling attendances finally put paid to their original use.

In 1931, Ernest G. Allen purchased the rooms and secured planning permission to convert the property into a 545-seat cinema. After much interior renovation, the cinema opened at 6.45 p.m. on Monday 22 August 1931, with the inaugural film being *Sunshine Susie* starring Renate Muller, Hack Hulbert, and Owen Nares. A seat in the circle cost 1s or 1s 3d and the cheaper seats in the stalls 7d and 9d.

The cinema closed in 1968, but was completely refurbished and reopened in May 1969. Under the management of the Lillis family, the cinema has gone from strength to strength and continues to provide a quality cinema experience for Marple residents. Its homely atmosphere makes for an individual viewing experience, with spacious and comfortable seating in both the stalls and the circle.

The Regent Cinema stands on Stockport Road, Marple.

46. Stockport Air-raid Shelters, 1938

By 1938, Britain was on the brink of war with Hitler's Germany. It would be the first war where aerial bombardment would play a significant part. The whole of the country was within easy reach of aircraft from the Continent, and the government feared that thousands of citizens might be killed in Guernica-style attacks.

Early in 1938, during a road-widening scheme in Chestergate, the demolition of several buildings revealed cellars that had been excavated by hand running into the soft rockface of the sandstone. With the crisis of war looming, it was decided to investigate the feasibility of tunnelling into the rock to provide secure air-raid protection for hundreds of people.

The corporation engineers were instructed to investigate and concluded that, for the most part, the rock was self-supporting and shelters could be constructed for the relatively low cost of 18s per yard.

Work on the shelters proceeded rapidly, although it went against government advice. The Home Office disapproved of large shelters, which, if taking a direct hit, would result in many hundreds of casualties.

Situated in the town centre, close to shops, offices and cinemas, the shelters were capable of housing several thousand people. They were remarkably dry, and ventilation was provided naturally by warm air rising through the tunnels

The shelters were built into the soft rock of the sandstone face.

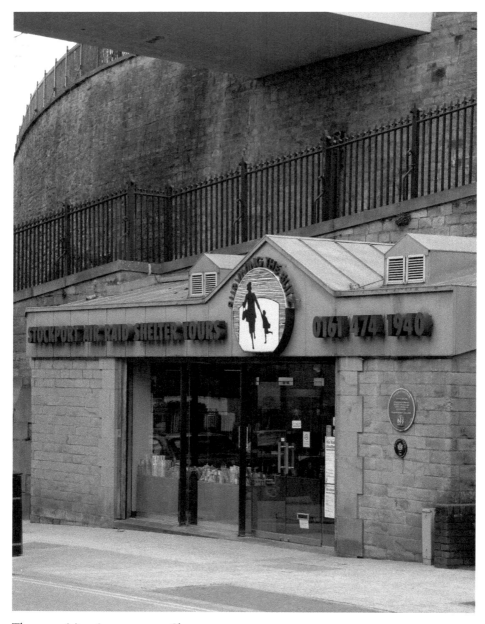

The new visitors' entrance on Chestergate.

to vent at the highest point. There were several ways into the shelters from the surrounding streets, and the entrances were sandbagged and dog-legged to protect from the force of blasts. The shelters included toilets, electric lighting, seating and first-aid stations. By the outbreak of war in 1939 the tunnels could provide shelter for around 4,000 people.

Throughout the most sustained period of air raids hundreds of people took up regular residence in the tunnels, but by 1943 only a handful of people were using the facilities. At this time the council decided to close the tunnels and hand the keys to ARP wardens for use only in emergencies. At the end of the war the tunnels were closed up as they stood and remained closed until opening as a major tourist attraction in 1996.

47. Merseyway Shopping Precinct, 1965

The precinct was opened in 1965 and was one of the first developments of its kind in the United Kingdom. In the 1990s, It was extensively refurbished including the creation of a new section of a covered mall at the western edge of the centre facing onto Mersey Square.

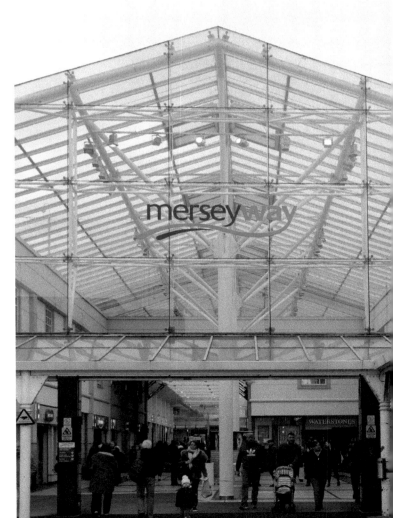

The shopping area with its recent glass roof addition.

After the Second World War, the 1947 Town and Country Planning Act required most towns and cities to produce a development plan. Stockport's plan was submitted but not formally approved until 1958. Part of the plan included the then fashionable development of an urban motorway or ring road in the form of the A560, which was the eventual blueprint for the M60. Stockport's proposal was designed to remove 'noise and fumes from Merseyway and in the spirit of urban renewal provide a pedestrian precinct where people can walk freely and safely without fear of being run down by intruding traffic'.

The architects, Bernard Engle and Partners, in conjunction with officers of Stockport Corporation, agreed on the plan to develop Merseyway, which involved building over the River Mersey to produce a centre that separated pedestrians and cars. Vehicles were only allowed access through the service areas. The new design incorporated a multi-level street system for shoppers. It was considered that the planning was emblematic of a new, ordered system that reflected a popular wave of modernism in the UK. Although not on the scale of constructions such as the Arndale Centre model, which swallowed whole towns, its clean, uncongested shopping area and the external travellators that whisked shoppers from one level to the next gave a tantalising glimpse of the futuristic shopping experience.

The largest benefactor of the development was the Co-operative society, which flanked the main square. It had its own car park with an entrance directly into the first floor of the store and incorporated a large clock tower into its design.

The names of the other businesses present in Merseyway throughout the 1970s produce quite a nostalgic roll call: Woolworths, British Home Stores, C&A, M&S and Rumbelows all had their presence in the thriving new development.

48. Strawberry Recording Studios, 1967

Strawberry Studios, situated on Waterloo Road, was founded in 1967 by Peter Tattersall, who had worked in the music industry for Brian Epstein.

Initially, his business was known as Intercity Studios, named after the newly formed British Rail service, and operated in a small space above Nield and Hardy's music shop in Stockport's shopping centre. However, when the lease was up a new home had to be found and, after securing some further investment, the larger premises on Waterloo Road were secured.

In an attempt to secure further funding, Peter approached local musicians Eric Stewart, who had played with the Mindbenders, and Graham Gouldman, who had a track record of penning hits for The Hollies, Herman's Hermits and The Yardbirds. His venture was successful and they were joined by art students Lol Crème and Kevin Godley. The four joined together and would go on to huge success as the band 10cc. The name Strawberry Studios was conjured up by Eric Stewart as a nod to the Beatles' Apple label.

The studios sit just outside the town centre on Waterloo Road.

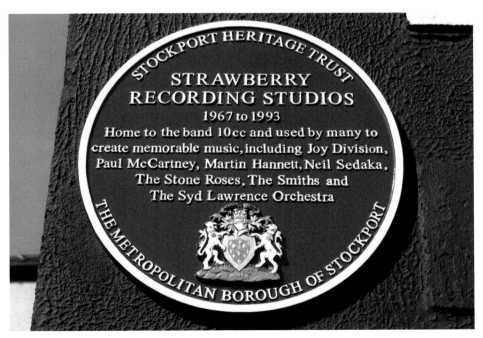

STOCKPORT HERITAGE TRUST

STRAWBERRY
RECORDING STUDIOS
1967 to 1993
Home to the band 10cc and used by many to
create memorable music, including Joy Division,
Paul McCartney, Martin Hannett, Neil Sedaka,
The Stone Roses, The Smiths and
The Syd Lawrence Orchestra

THE METROPOLITAN BOROUGH OF STOCKPORT

A plaque next to the entrance remembers famous recording artists.

The success of Strawberry Studios was immediate, attracting musicians because of its well-equipped facilities. The list of acts in its early days was impressive. Eartha Kitt, The Ramones and Neil Sedaka graced the studios, the latter using the then-unknown 10cc as his backing group. The Bay City Rollers called in to record 'Bye Bye Baby' and Paul McCartney booked the studio for his brother, Mike McGear. St Winifred's School Choir turned up in force to record 'There's No One Quite Like Grandma', but perhaps the biggest hit recorded there in the 1970s was 10cc's 'I'm Not In Love'.

During the 1980s and 1990s, the studio faced more competition because recording became less expensive and the number of rival companies multiplied. Peter Tattersall sold Strawberry Studios to its local rivals, Yellow 2 Studios, in 1986. The name was retained but the studio eventually closed in 1993.

49. The Pyramid Building, 1992

It would take some searching of the mind to find a connection between Stockport and Egypt's Valley of the Kings. While the Mersey does not quite meander with the purpose and splendour of the Nile, it does flow steadily past a construction that pays homage to one of the great dynasties in world history.

Travelling around the M60, Stockport Pyramid has become a significant marker for people making their way to the town. Junction 1 of the motorway has even taken its name, being known locally as the Pyramid Junction. It is a curious late 1980s, early 1990s construction of blue and clear glass, designed by Christopher Denny from Michael Hyde and Associates, and rises above the drab urban surroundings of what was once the residential area of Huntsman's Brow. Interestingly, the residents called this area 'The Valley' as it was situated at the front of a sheer rockface that was underneath an old chimney that faced out onto Huntsman's Brow. Sadly, the community and its houses, pubs and small businesses were swept away in the name of urban regeneration. The Pyramid was intended to be the first of five similar constructions that would form the £20 million development of Kings Valley, stretching west from the centre of the town.

However, this vision of commercial development never came to fruition. The building was completed in 1992 but the resulting economic downturn caused the project to be abandoned, and the developers went into administration. The vision of Kings Valley was lost forever, leaving only the Pyramid to stand alone and empty until 1995 when it was repossessed by the Co-operative Bank. It was turned into their telephone call centre, with 1,600 staff occupying its five separate floors and 86,000 square feet of office space.

Today it is one of Greater Manchester's iconic landmarks. It may not survive as long as its Egyptian counterparts, but whether you are approaching the town by rail, air, car or on foot, your eye will inevitably be drawn to this distinctive building, which sits proudly at the gateway to the town.

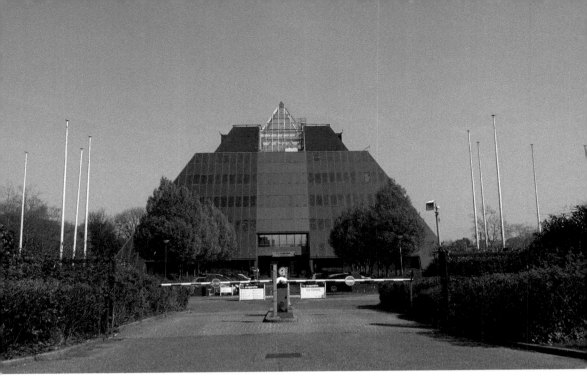

Above: The Pyramid is an iconic landmark next to the M60.

Below: The location of the Pyramid before the area was redeveloped.

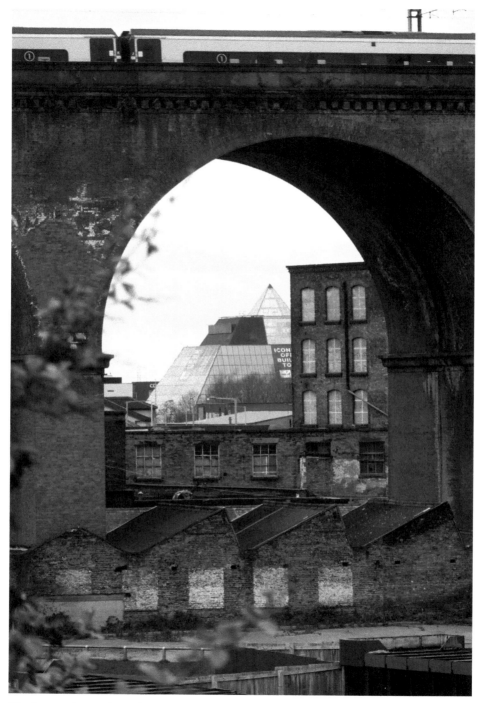

The Pyramid seen through Stockport's railway viaduct.

50. Red Rock, 2017

If there's one thing that can be said about Stockport's Red Rock development it is that it polarises opinion among the people of the town. The £45 million venture, which opened in November 2017, features a cinema, restaurants and bars and was designed by BDP, the architectural firm formerly known as Building Design Partnership. Its flat-packed presence dominates the opposite side of the M60 from Stockport's real red rock, a bed of Permian and Red Triassic sandstone laid down over 240 million years ago.

In 2018, Red Rock was shortlisted for the Carbuncle Cup, an architecture prize given annually by the magazine *Building Design* to the ugliest building in the United Kingdom completed in the previous twelve months. The name derives from a comment by Prince Charles, who described the proposed extension of London's National Gallery as 'a monstrous carbuncle on the face of a much-loved and elegant friend'.

Justifying its inclusion on the shortlist, the judges commented:

> Stockport's new £45m leisure centre is one of the worst architectural responses ever conceived for Greater Manchester. An awkward row of disjointed boxes lines the M60, unhelpfully signalling Stockport's aesthetic peril to motorists.

The new development of Red Rock overlooks the M60.

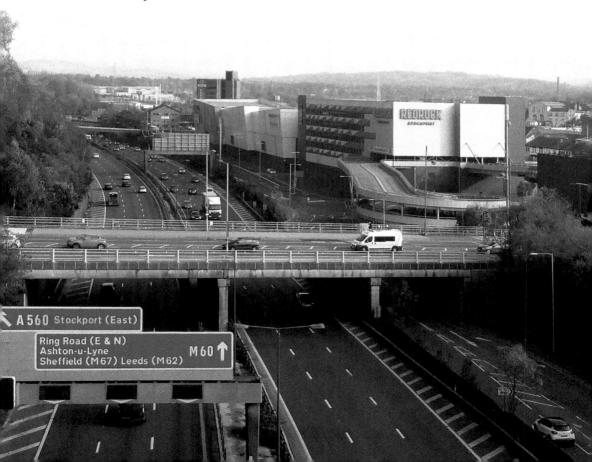

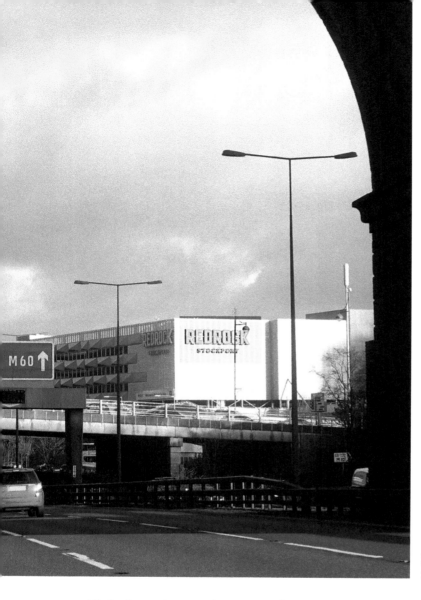

Red Rock viewed
from the M60.

All the boxes lean at alarming angles and are then sheathed in all manner of
insalubrious multi-coloured cladding. Urban regeneration can be a good thing.
When it becomes an excuse to foist bad architecture onto struggling communities
in the cynical pursuit of an 'anything is better than what was there before'
methodology, it simply recycles the resentment regeneration was supposed to
redress.

When the decision was announced, Red Rock came out as the clear winner.
However, those involved with its development and promotion insist it is swiftly
becoming a 'must-visit leisure destination' and is developing in popularity with
the locals.

Bibliography

I would like to acknowledge the following publications, which were invaluable sources of information when researching many of the key facts for this book:
Astle, William OBE JP, *A History of Stockport* (SR Publishers Ltd, 1971)
Garrett, Morris, *Stockport Revisited* (Tempus Publishing Ltd, 2006)
Garrett, Morris, *Stockport: A History* (Phillimore and Co. Ltd, 2009)

Acknowledgements

I would like to give special thanks to the following people who have helped with the content of this book. Peter Adamson for his photograph of Staircase House. Phil Rowbotham for his photograph of Barnes Hospital. Molly Page for her photographs of Stockport Viaduct at night and Blossoms at the Plaza Theatre. Jack Cawthorne and Alessandro Mercogliano for their photographs of Edgeley Park. Dr Carole Page for her photograph of the interior of Stockport Central Library. W. Rhodes Marriott AIBP, ARPS for his photograph of the Plaza from 1953. Dave Walker for his aerial picture of the Arden Arms. Their copyright is hereby acknowledged. Thanks also go to Dr James Page for supplying facts relating to the history of Peel Moat.

About the Author

Phil Page is a photographer and writer who has lived in Stockport since 1981. He is a former secondary school English teacher and has also worked in teacher training for Manchester Metropolitan University. This is his seventh publication for Amberley, the previous six being: *The Four Heatons Through Time*, *The River Mersey From Source to Sea*, *The Four Heatons Postcard Collection* and *From Bugsworth to Manchester*; and *Secret Manchester* and *Secret Stockport* were co-written with his colleague Ian Littlechilds. In addition to writing books, he is *Moor Magazine's* history features writer and delivers talks on local history to community groups in and around Stockport.